Footprints of the Gods

THE POINT LOBOS SAGA

Point Lobos, California

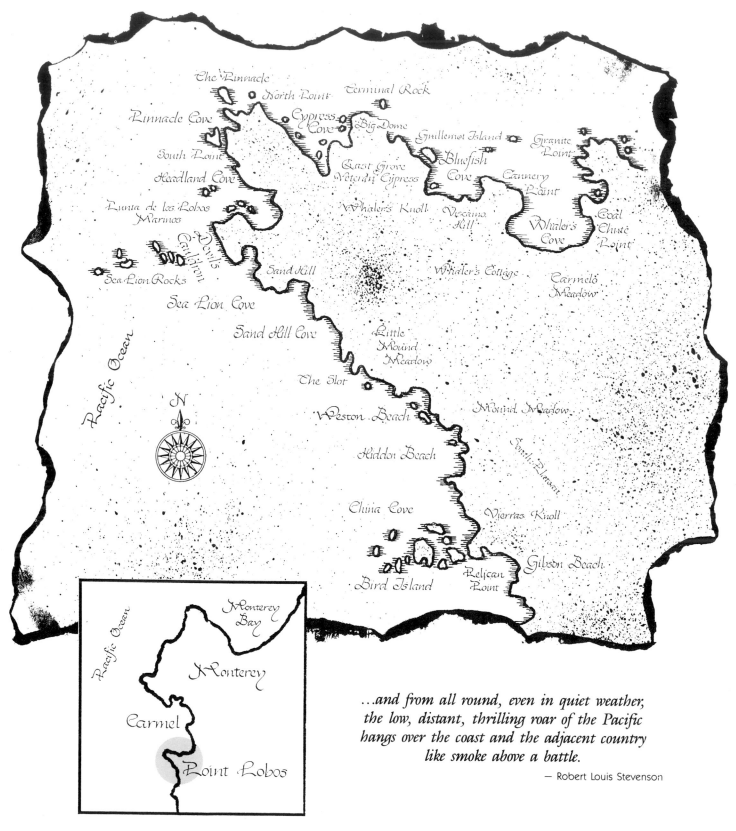

...and from all round, even in quiet weather,
the low, distant, thrilling roar of the Pacific
hangs over the coast and the adjacent country
like smoke above a battle.

— Robert Louis Stevenson

But (Stevenson) always went back to Point Lobos, his head afire with tales and stories;
the cave of gold engulfed at the foot of Big Dome; the galleon shipwrecked near the Pinnacle;
the boats of the clandestine Chinese gliding through the night; the lost treasure of
Sir Francis Drake; and he would spend hours seated on the rocks, looking out at nothing....

— Michel Le Bris

Footprints of the Gods

THE POINT LOBOS SAGA

L U C I E N C L E R G U E

Essay by Jim Hughes

Iris Publications, Inc. • *Boca Raton, Florida*

Photographs and text copyright ©1988
by Lucien Clergue.

"Signs of Life and Death" copyright ©1989
by Jim Hughes.

Map on page 2 copyright ©1989
by Iris Publications, Inc.

French edition published by Teledition, Genève,
1989, by arrangement with Iris Publications, Inc.

First edition.

**Library of Congress
Cataloging-in-Publication Data**

Clergue, Lucien
 Footprints of the Gods.

 1. Photography, Artistic — Exhibitions. 2. Nature
photography — Exhibitions. 3. Point Lobos
Reserve — Description and travel — Views —
Exhibitions. 4. Clergue, Lucien — Exhibitions.
I. Hughes, Jim, 1937-
II. Title.
TR654.C583 1989 779'.092 89-7577
ISBN 0-925965-01-4
ISBN 0-925965-00-6 (pbk.)

This book and exhibition have been sponsored by
a grant from Eastman Kodak Company, Professional
Photography Division.

Any inquiries about this book as well as about the
exhibition, and availability of prints by the artist,
should be directed to the publisher:
Iris Publications, Inc.
1900 Corporate Blvd., NW
Suite 308 West
Boca Raton, FL 33431
(407) 997-8677.

Printed in the United States of America.
Eastern Press, Inc.
New Haven, CT

NOTES
The quotations referenced below appeared in French
language texts. The translations for *Footprints of the Gods*
were made initially by Connie Paladino with final editing
by Jim and Pamela Knight.

Page 2: Michel Le Bris, *La Porte d'Or,* (Paris, Societe des
Editions Grasset et Fasquelle, 1986), p. 188.

Page 15: Saint-John Perse, unpublished dedication to
Lucien Clergue, 1967, Collection Lucien Clergue.

Page 16: Pierre-Jean Jouve, "Les Noces", in *Enfants
Mystérieux: Magie,* (Paris, Mercure de France, 1964), p. 48.

Page 26: Michel Leiris, "Haut Mal", in *Failles: Hymne,* (Paris,
Editions Gallimard, 1943).

Page 44: Ovid, *Les Métamorphoses,* translated by Joseph
Chamonard, (Paris, Flammarion 1966), p. 43.

Page 62: Roland Barthes, "Notes sur un Album de
Photographies de Lucien Clergue", in *Langage des Sables,*
(Marseille, Editions AGEP, 1980), 3rd folio.

Page 90: Jean Giono, *Le Poids du Ciel,* (Paris, Editions
Gallimard, 1938), p. 193.

The quotations referenced below appeared in English
language texts.

Page 2: Robert Louis Stevenson, *Across the Plains,* (New
York, Charles Scribner's Sons, 1910), p. 79.

Page 20: Roger Caillois, *l'Ecriture des Pierres,* translated by
Barbara Bray in *The Writing of Stones,* (The University
Press of Virginia, Charlottesville, Virginia, 1985), p. 78.

Page 34: Saint-John Perse, "Amers", in *St.-John Perse
Collected Poems,* translated by Wallace Fowlie, (Princeton,
New Jersey, Princeton University Press, 1971), p. 517.

Page 52: Gaston Bachelard, *L'eau et les rêves,* translated
by Edith R. Farrell in *Water and Dreams,* (The Dallas Institute
of Humanities and Culture, Dallas, Texas, 1983), p. 152.

Page 72: James Laughlin, "Made in the Old Way", in *New
Directions in Prose & Poetry 1938,* (Norfolk, Connecticut,
New Directions, 1938, reprinted by Kraus Reprint
Corporation, New York, 1967), p. 289.

Page 82: William Shakespeare, "Sonnet 146", in *The
Shakespeare Sonnet Order,* Brents Stirling, (Berkeley and
Los Angeles, California, University of California Press,
1968), p. 223.

Page 94: Robinson Jeffers, "Inscription for a Gravestone",
in *The Selected Poetry of Robinson Jeffers,* (New York,
Random House, 1937), p. 480. Copyright 1931 by Random
House, Inc. and renewed 1959 by Robinson Jeffers.
Reprinted by permission of Random House, Inc.

To the memory of Robert Louis Stevenson
who dreamed of Point Lobos as Treasure Island;
To Edward Weston, who, while immortalizing
Point Lobos, gave me the key of my life in
photography;
To Wynn Bullock, my guide through the rocks
of Edward Weston;
To Virginia and Ansel Adams, godmother and
godfather of my Point Lobos adventure; and
To the students of my workshops, who have
always encouraged me to keep on going.

Lucien Clergue

Contents

TWELVE YEARS AT POINT LOBOS
by Lucien Clergue

In 1971, while I was in San Francisco, Jack Welpott and Judy Dater introduced me to the West. They drove me down to Carmel to meet Wynn Bullock. This wonderful man was my guide through the world of Edward Weston — every rock, beach, cypress tree and bay brought back memories of him. I was so moved that my first roll of film was damaged — nothing on it, completely blank. We later went to have cocktails at Virginia and Ansel Adams' home. The West was beginning to work its charm on me. To complete the tour, we made a pilgrimage to Weston's old studio, which had been built by Neil in the twenties.

From then on, I went back to Point Lobos almost every year, to be met at the airport by Mrs. Salinger (Pierre's mother), and hosted by Virginia and Ansel. To wake me up early in the morning, he used to imitate a donkey's "Hee-haw, hee-haw!" outside my room — and would laugh when I opened the door! None better than he to cook my eggs "sunny side up." One day, when I came back soaked to the skin after a shooting session with a model (who had protected me from the onslaught of the waves), Virginia told me "every year four or five people disappear in the ocean." Weston's ashes were scattered on that particular beach, and his presence is so strong that it is as though he does not like one to work too much there. (It has been named Weston Beach).

Some time after that, I discovered color — all the subtle range of color tones at low tide, when all the chimeras show up. People used to follow me, at a distance; when they could no longer resist it, they would ask me, "What are you photographing here?" How could I explain? I did not know myself. Nothing, anyway, like Weston or Adams. I brought my Mediterranean spirit there — my own world, to match that of the greatest photographers, the famous F-64 group.

In 1983, Ansel invited me to be part of a workshop he was giving. I brought my students to Point Lobos; while they were busy at China Cove, I went around to the other side — blue, morning light, and for the first time, I saw the death-masks! I was so happy to be at Point Lobos — to get back to origins: it was such a marvelous symbol of life — all those signs left by gods and goddesses; preparing a human life. But life and death go together: the year after, Ansel died. My story was over. I never returned to Point Lobos.

When Minor White complained once to Weston that, because of him, he could not photograph at Point Lobos, Weston replied, "Oh no! I just scratched the surface of Point Lobos with my fingernail, but everyone who wants to go there and express himself should do so."

I did. Here, then is my Point Lobos Saga. Putting it together almost killed me. I survived, but the world will never be like it was before. And the questions remain for all eternity: why, why, why? Why are there the two sexes, man and woman? Why is there a bestiary, making you think of Hieronymus Bosch? Why this dream of nature? Why death, suddenly all around you? Why? Why? Why?

In the concept of the universe, life and death are on the same level, on the same line, in the same hour. But between the two, there is so much to be seen and done: let us try and discover this secret world of nature.

Lucien Clergue
Boca Raton, Florida
November 3rd, 1988

Note: *My interest at Point Lobos was focused on the following sites — Sand Hill Cove, the Slot, Weston Beach, Hidden Beach and China Cove — with a brief incursion into Gibson Beach. All the photographs were made using Kodachrome film with a Minolta camera and lenses.*

SIGNS OF LIFE AND DEATH
by Jim Hughes

"I have never seen the sea quiet round Treasure Island," wrote Robert Louis Stevenson's young narrator, Jim Hawkins.[1] "The sun might blaze overhead, the air be without a breath, the surface smooth and blue, but still these great rollers would be running along all the external coast, thundering and thundering by day and night."

Legend has it that Stevenson set *Treasure Island* on the rugged Monterey peninsula in California, just north of Carmel and Point Lobos. A modern map of the area, outlined by the famous 17-Mile Drive, bears a striking resemblance to the book's fictional pirate chart, right down to such landmarks as Spyglass Hill. And it is a fact that Stevenson for a time lived nearby, while courting his wife to be.

As it does in Stevenson's classic adventure story, the relentless sea plays a pivotal role in Lucien Clergue's photographic saga of Point Lobos, a magical headland in sight of the Spyglass. "Perhaps I, too, sought a treasure," says Clergue from his home in the south of France, his marvelous *Provençal* accent resonating by satellite across the Atlantic.

Lucien Clergue certainly is not the first to have searched for images at Point Lobos, a place that for more than half a century has become so synonymous with Edward Weston that a beach there bears the legendary photographer's name. Camera clubs for years have made pilgrimages to be shown precisely where Weston placed his tripod legs so that members might dutifully duplicate his efforts. And Clergue himself says he went to Point Lobos in 1971 "to give a tribute to Weston."

"In the beginning, it was just to check my intuition about some things already done by Edward," Clergue remembers of his original efforts in black and white. Clergue at first brought a model to pose nude in the landscape, but soon was concentrating on the land itself. His black and white studies from Point Lobos became, Clergue says, the key to a new body of work, *Language of the Sands,* to be published nine years later, in 1980. (This work, which also encompassed photographs of natural formations from the beach at the Camargue, where the Rhone meets the Mediterranean,

became the basis of Clergue's doctoral thesis at the University of Provence; the late Roland Barthes, a member of the jury, wrote the introduction for the book.)

In 1974, Clergue returned to Point Lobos. Although in traditional view camera territory, the Frenchman, never a purist, began exposing color film in his 35mm single-lens reflex cameras and using, for the most part, a 50mm macro lens. "I never used a tripod because I was always afraid a tripod would hurt something," he says. "I was thinking you have to protect the environment. I even took care to wear the proper shoes, to not hurt the surface of the fragile rock and sand.

"I always remember that Edward Weston said that he just makes photographs on top of Point Lobos, but it's open to everybody. He wanted people to come after, and find something new.

"At first, I didn't know what I was finding, in the larger sense. I was collecting signs for which I had not really an idea. It is always the same. It takes me a long time, because I never go with the thought of building a story. I am gathering material. It is a little bit like a writer who publishes an episode in a magazine, and at the end it becomes a chapter in a novel. I just collect pieces.

"You know, they are so strong, the things you see. You cannot be seeing that way, with such intensity, for too long, because then your eyes become tired, and you lose the kind of emotion you need to discover. So I would only photograph for two, three days, and then after six months go back, and then after a year, and again six months later. This went on for 12 years."

And all the while, the waves continued to thunder and roll. "The erosion is working so hard," Clergue explains. "Degrading, destroying those rocks, the fragile ones, and giving to us the ones that are strongest. Those are the ones I am photographing. Yet some surfaces I shot ten years ago do not exist in that form anymore. Even in the comparatively short time I have been photographing at Point Lobos, there are things I cannot see any longer. And then there are formations that are still there, that have been there a hundred, a thousand years."

Lucien Clergue is a man of complex sensibilities. Born in Arles in 1934, Clergue seems to have lost his childhood to the second World War and its consequences. When he was seven, his parents divorced, and he remained with his mother, in an apartment above her small grocery store. In the spring of 1944, with the Allied Forces on the verge of liberating southern France, the children of Arles were dispersed out of town; little Lucien went to live with a family on a nearby farm. Eight months later he returned to find his home, and much of the town, in ruins. His mother's store was destroyed.

After succeeding in reopening her business, Lucien's mother subsequently fell ill. When she

eventually became bedridden, Lucien, at the age of 16, left school to work in the store and care for his mother. She died in 1952, by which time he was working in a factory to support the two of them and pay her medical bills.

It was the mother's hope that the son become an artist. When he was younger, he had studied violin, but gave it up after several years for lack of funds. Now, suddenly alone, the young Lucien Clergue looked for solace to poetry, painting and film. Italian filmmakers in particular inspired him, and for a while Clergue entertained the idea of making films himself. Finally he realized that, again, he lacked the necessary resources.

Instead, he learned to focus his artistic interests through the still camera. Fascinated by the portraits of matadors made by a local photographer, Clergue began to ask questions. Before long, he was taking photographs himself. Then, at 19, Lucien met Pablo Picasso. The year was 1953, and the place was the bullring at Arles. Clergue worked up the courage to show his photographs to the man recognized as perhaps the greatest living master of modern art. Picasso asked to see more work in a year.

It would be two years before the young man felt he had a portfolio worth showing. By then, in addition to photographing the war ruins of Arles, he had completed several theatrical sequences including one on Jean Renoir's 1954 production of "Julius Caesar" and another entitled *Les Saltimbanques,* a 1955 series of portraits meant to recall the itinerant troupes of performers, from acrobats to clowns, who centuries before roamed the French countryside.

Clergue posed his young actors in the bombed out shells he had earlier photographed. At first he called the series *The Long Recess,* an ironic reference, writes Marianne Fulton in an essay accompanying Clergue's retrospective book, *Lucien Clergue: Eros and Thanatos,* ". . .to the time immediately after the war when the school in Arles was in ruins and no classes were held. What should have been a child's ideal and joyful time was instead a period of depression and uncertainty, which seemed to last forever. As children, the subjects. . . do not play at all but appear lethargic, perhaps even in shock. As circus or *comedia* figures, they do not act, do not laugh, do not dance. They are wanderers in a devastated world; performers without an audience. The costumes (made by Clergue himself). . .take them out of the present and suspend them in time."[2]

Consciously or not, Clergue was already creating photographs that could stand as metaphors for his own life. These and a number of other images, including

mannequins and masks on junk heaps and a variety of dead animals washed up on riverbanks and on beaches, were sent by the aspiring photographer to Picasso, who recognized in them elements of surrealism. In Clergue's hands, even found objects had in them a sense of theatre — and tragedy.

In 1955, when the two men met for the second time, Picasso and Clergue formed what would be a lasting friendship. Later that same year, at Picasso's urging, Clergue introduced himself to the French dramatist, Jean Cocteau, and embarked upon a long collaboration that would profoundly influence his work. Indeed, Clergue's first published photographs were those chosen by Cocteau for an edition of poems by Paul Eluard, *Corps memorable,* with an introductory poem by Cocteau and a cover designed by Picasso.

The photographs were of female nudes, mostly reclining in water, bathed in waves. They marked the beginning of a new direction for Clergue, the antithesis of the death that infused his earlier work. Clergue's first book of nudes, *Aphrodite,* published in 1963, seems less about the women depicted than about the search for a mythic ideal, a life force abstracted. By then, Clergue had been exposed to another major influence, the photographs of Edward Weston.

"I did the first nudes in 1956," Clergue explains, "and at that time in France we had no [photography] magazine of a serious nature. Then came *Foto Monde,* and one cover was the famous Weston nude [of Charis]. That was such a shock, you have no idea. For me, it was a revelation, because the only nudes I knew at this time were published in the nature magazines, where they retouched the sex, made the women without sex. They were just awful for me.

"I remember showing such a magazine to a friend and saying, 'I will do the nude and I will show everything.' And then I saw the Weston and I was just living with this fabulous nude in front of me, the influence of Weston has been so strong.

"You have to consider the work of Edward Weston in the time he did it, with the influence of the Mexican people and his transferring the idea of the vegetable forms to the rocks and trees of Point Lobos. In such a very simple way, he was opening our eyes. You have to realize that Edward Weston's work came just before the great period of the surrealists, while I am of the generation that has been very much entranced by the vision of surrealism."

In his *Daybooks,* Weston addresses the issue of symbolism in his work by disclaiming intent: "...There have been many who find phallic symbolism in my photographs...'reproductive organs' in kelp, vegetables, rocks, peppers — natural forms....Only with effort could I find more than faint resemblance to 'reproductive organs' in any of my prints: besides, there could not be phallic symbolism where none was intended or felt — in fact no symbolism of any kind was intended.

"...If there is symbolism in my work, it can only be in a very broad consideration of life, the seeing of parts, fragments as universal symbols, the understanding of relativity everywhere, the resemblance of all natural forms to each other."[3]

But in Clergue's photographs, the symbolism — phallic or otherwise — is intentional. "I am a Mediterranean-cultured man, and I bring it with me, to America, to Point Lobos," Clergue offers by way of explanation. "The vision I had about those symbols of life and death and sexuality, this is probably typical of a man from the south of France. People with a North American point of view will not see in the same way.

"I always visited with Ansel Adams when I was shooting at Point Lobos. He saw a lot of the pictures, and he was very surprised. 'After 40 years of going there,' he'd say, 'I never saw what you see.' But Ansel never made the nude. He said he was from a different generation. His eyes didn't want to see those signs which are so plain."

Nonetheless, Clergue, the Mediterranean man, credits two American photographers with having been major influences on his work: Edward Weston, for his clear, direct ways of seeing, and Minor White. "Minor, with his sequences, showed me how to build a symbolic story," Clergue explains. "Before Minor, the concept of a non-narrative story, told visually, abstractly, with an assemblage of pictures one after the other, did not exist."

Minor White's philosophy was a blend of East and West. He wrote, for example, that ". . .the state of mind of the photographer while creating is a blank. . .a very receptive state of mind, ready at an instant to grasp an image, yet with no image pre-formed. . . . Such a state of mind is not unlike a sheet of film itself. . . .

". . .The photographer projects himself into everything he sees, identifying himself with everything in order to know it and feel it better. To reach such a blank state of mind requires effort. . . ."[4]

It also requires, as White observed, a certain innocence, an ability ". . .to see as a child sees." With concentration, White believed, the photographer, while photographing for what a thing is, may reach the point where he photographs for what else it might be.

"In my story of Point Lobos," Clergue offers, "I begin with the big waves, to show a situation: where we are, yes, but most important to show that everything that follows comes from the energy of the ocean. The beginning of life. Then I introduce the first signs, human symbols, witnesses, perhaps, to a lost civilization, like the Incas or Mayas. It is structure more than identification. Then I go inside the sexuality of this territory, with more precise male and female symbols, then to dreams — the dream of nature, the nature of dreaming: copying yourself, like you are the reproduction. A bestiary follows, but the animals are mythic monsters, as from Bosch and Breughel. Then chimeras, another sort of dream, like nightmares. I end with the death symbols, and the last sequence is the galaxies, to which all life returns.

"I came to the conclusion that in the course of the universe, life and death are the same level, the focus of the same point."

Clergue made his color photographs at Point Lobos between the years 1976 and 1983. The work began to come together as a book in

1984. Death was on his mind. The year before, he had returned to the Carmel area, to be part of Ansel Adams' summer workshop.

"Until then, I always found signs of life at Point Lobos, but for the first time, I began to find signs of death," Clergue remembers. "A few months later, Ansel died. In my mind, the events were related. I went back for Ansel's memorial. I was thinking, 'Let's go to Point Lobos and revive yourself, find those signs of life that are so good for you.'

"I spent a full day, from dawn to dusk, and I found only signs of death. I photographed what I saw, and left, intending not to go back. In 1984, I was 50 years old. My mother died when she was 50, and I had always been thinking that I, too, would die when I was 50. I wasn't making plans for the future. Now I am 54. Life goes on.

"My work as a whole is kind of a trilogy: life, in the nudes; death, in the dead animals and the bullfights; and in the middle, the landscape, which is liberating the limits, in the sense of universe.

"I have been doing the landscape seriously since 1959. In the beginning, when I worked in the Camargue, I didn't make any symbolic representations. But by the time of Point Lobos, it was so obvious to me."

Clergue describes his discovery of a netherworld of gods, goddesses and attendant creatures and dreams recorded in the very stones of the earth as nothing less than supernatural. But as his intricately sequenced pictures show, the photographer went beyond mere documentation: by articulating a compelling context, he has managed to penetrate the ageless mysteries of this hitherto hidden universe and present them in a clear, informed, and moving manner. In his multi-layered work, one encounters a panoply of symbols, graven images created not by man, but by nature.

Clergue had the conviction to grasp the revelation, the vision to make its meaning his own, and the uncommon skill to build a work of imagination out of water, stone, light, and color. Although his language is visual, even sensual, the overall structure he has applied to his work is poetic, and draws upon literary sources rich in mythic values.

Unlike so many contemporary photographers, Clergue in his career has rarely focused on the outward manifestations of man's supposed superiority: the steel and concrete edifices, for example, that testify to our puny ingenuity. From the beginning, Clergue's art has been concerned with the natural order and man's place in it.

The Point Lobos photographs are part of this continuum, perhaps the most probing part so far. Follow the sequence of this book from front to back, or back to front: the whole turns on the endless wheel of life, a metaphor for art and artist both.

For Lucien Clergue, and perhaps only for him, certain profound signs of life and death, sculpted by irresistible forces, were waiting to be seen and interpreted. There, written in stone, Clergue saw the story of creation, a veritable Bible told in the ancient and universal language of images.

NOTES:
1. Robert Louis Stevenson, *Treasure Island,* (New York: Grosset & Dunlap, 1976), p. 214.

2. Marianne Fulton, *Lucien Clergue: Eros and Thanatos,* (Boston: New York Graphic Society, 1985), p. 17. Fulton's text also provided many biographical details of Clergue's early life, and the author wishes to express his appreciation for such an excellent source.

3. Edward Weston, *The Daybooks of Edward Weston: California,* (New York: Horizon Press, 1966), p. 224.

4. Nathan Lyons, Ed., *Photographers on Photograhpy,* (Englewood Cliffs, N.J.: Prentice-Hall, 1966) pp. 165-66.

Lucien Clergue, who looks for
destiny's face under the most faithful
masks of this world.

— Saint-John Perse

BIRTH

One night when the sea penetrates
the countries of the mountain
One night when one is younger
than in youth...

— Pierre-Jean Jouve

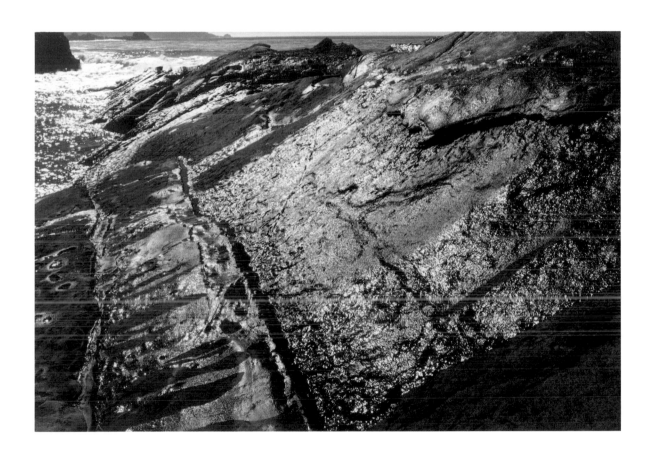

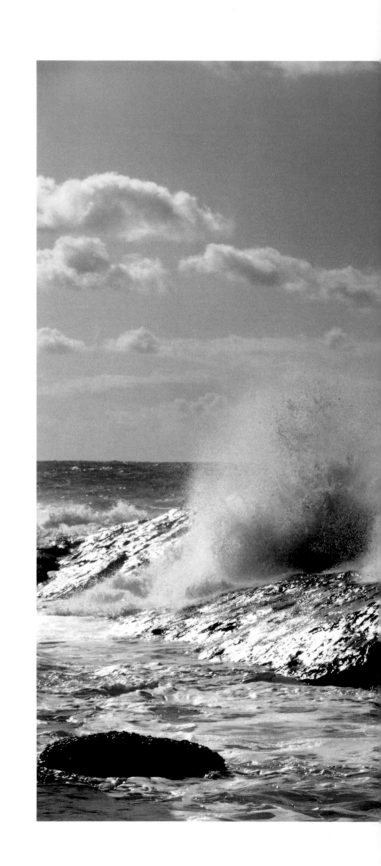

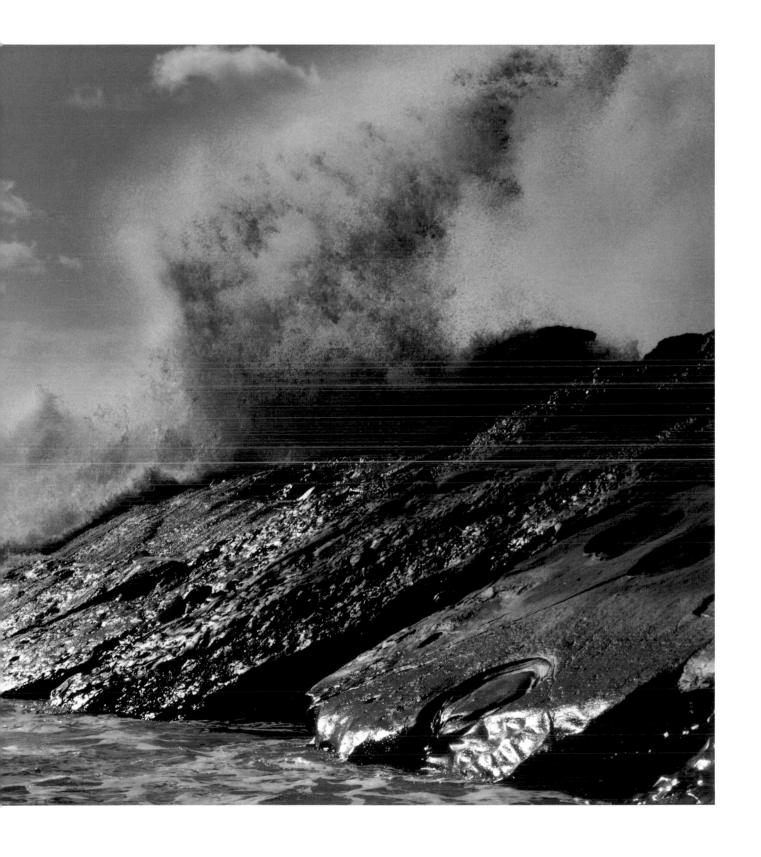

CRADLE ROCK

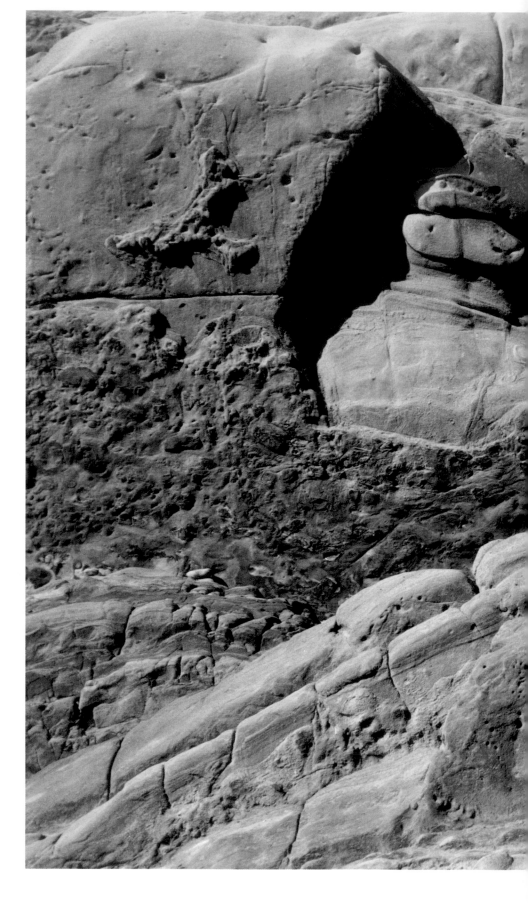

The vision the eye records is always impoverished and uncertain. Imagination fills it out with the treasures of memory and knowledge, with all that is put at its disposal by experience, culture, and history, not to mention what the imagination itself may if necessary invent or dream.

— Roger Caillois

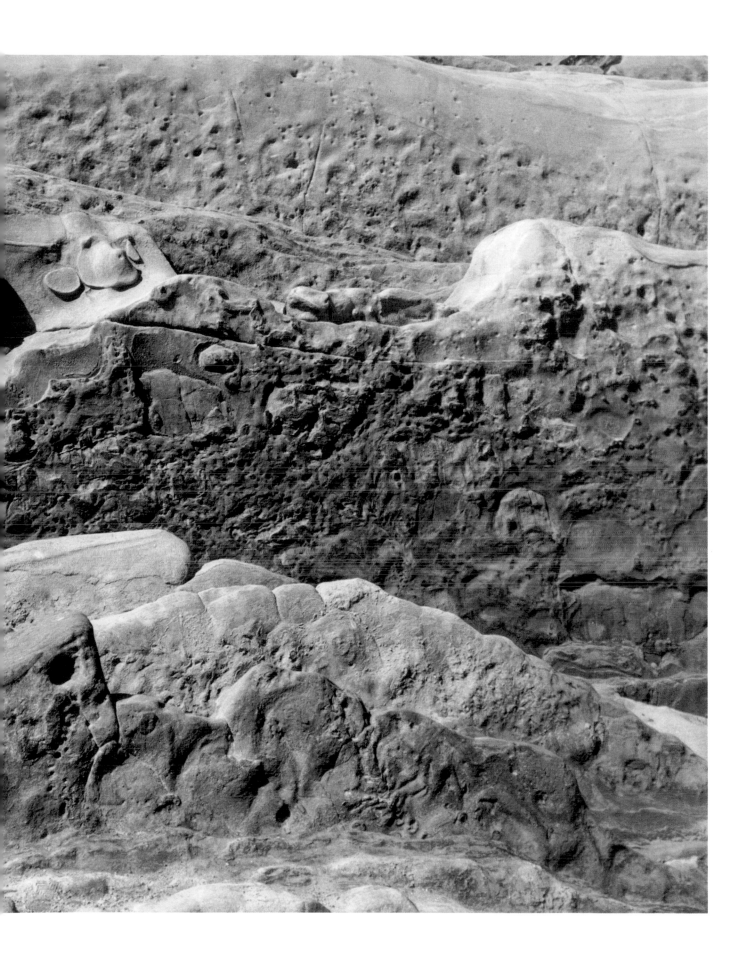

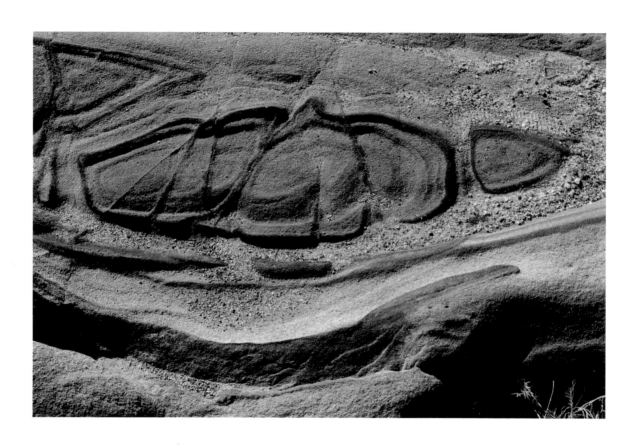

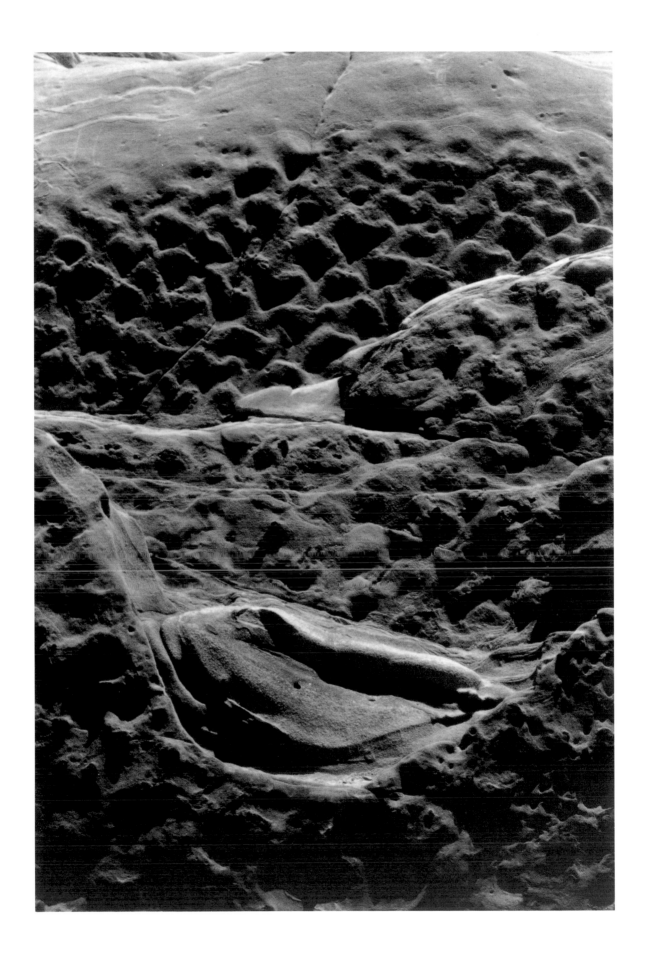

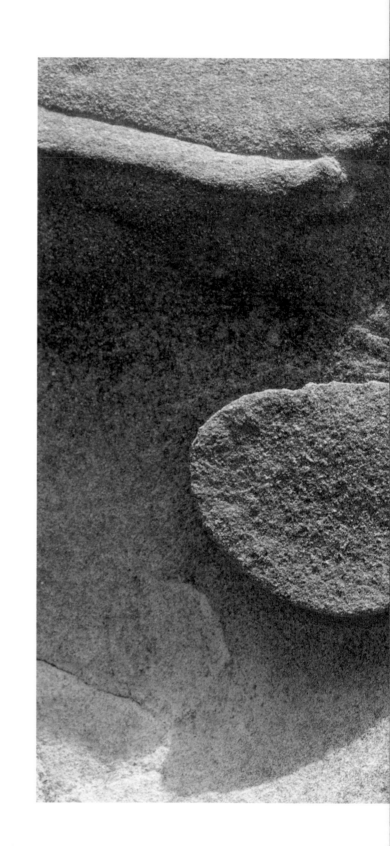

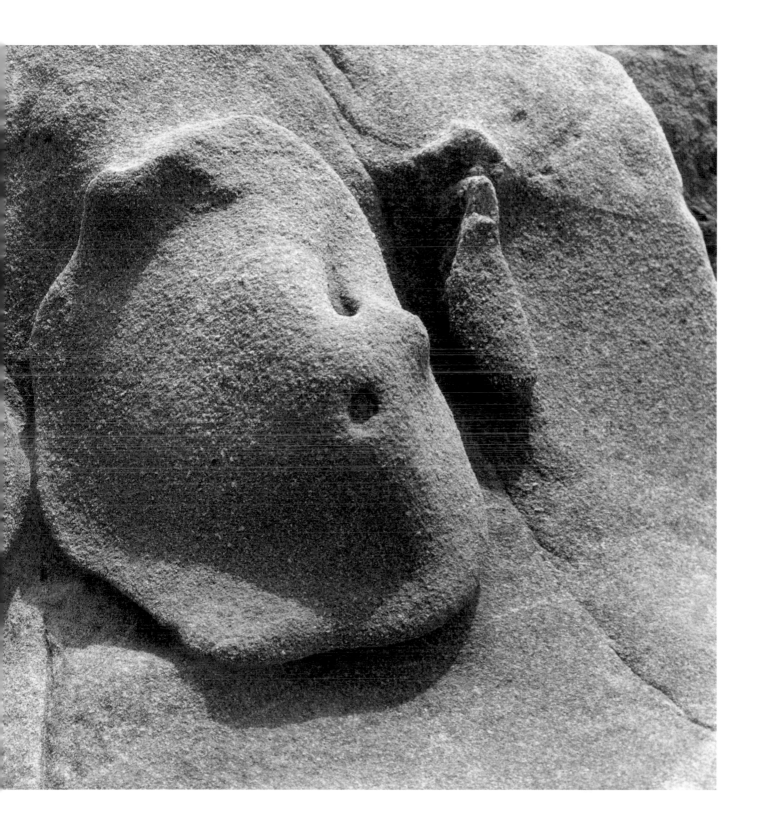

*H*UMANITY

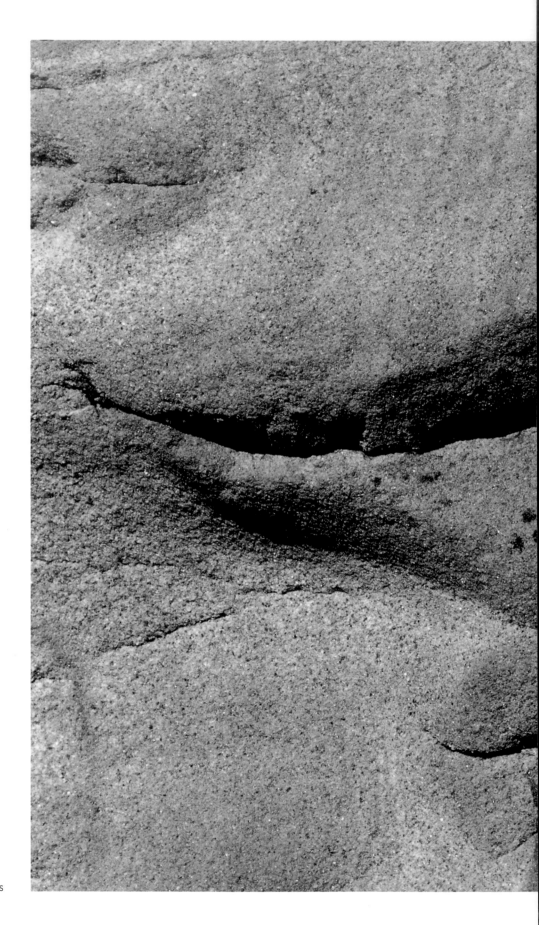

Here are our mouths
and the clock at midnight moves
them apart.

— Michel Leiris

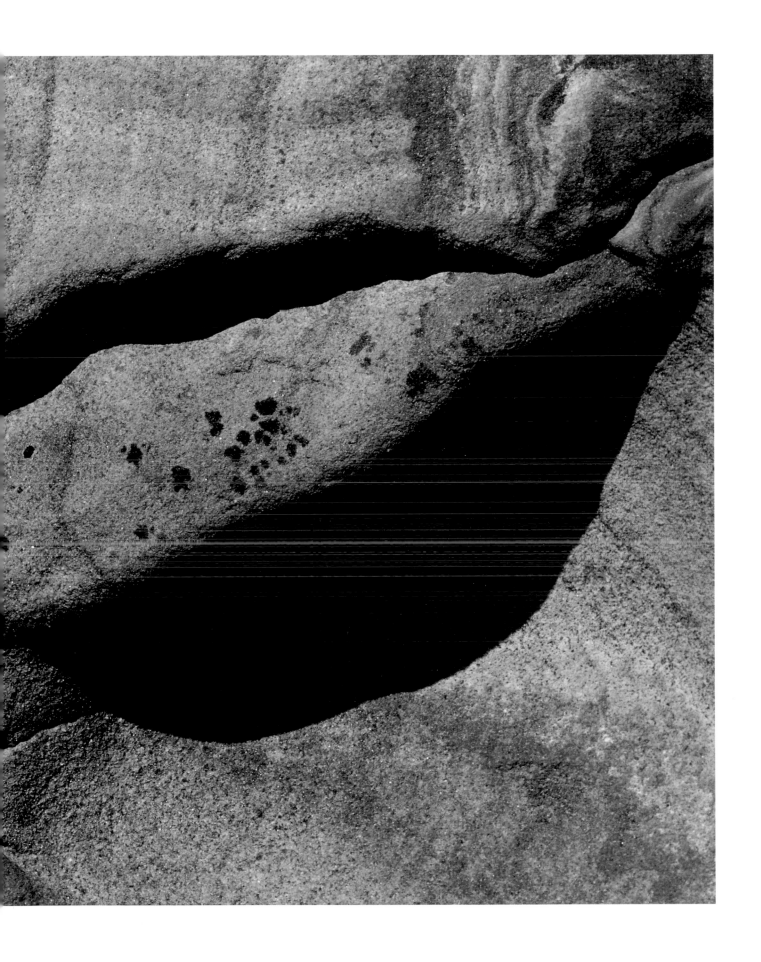

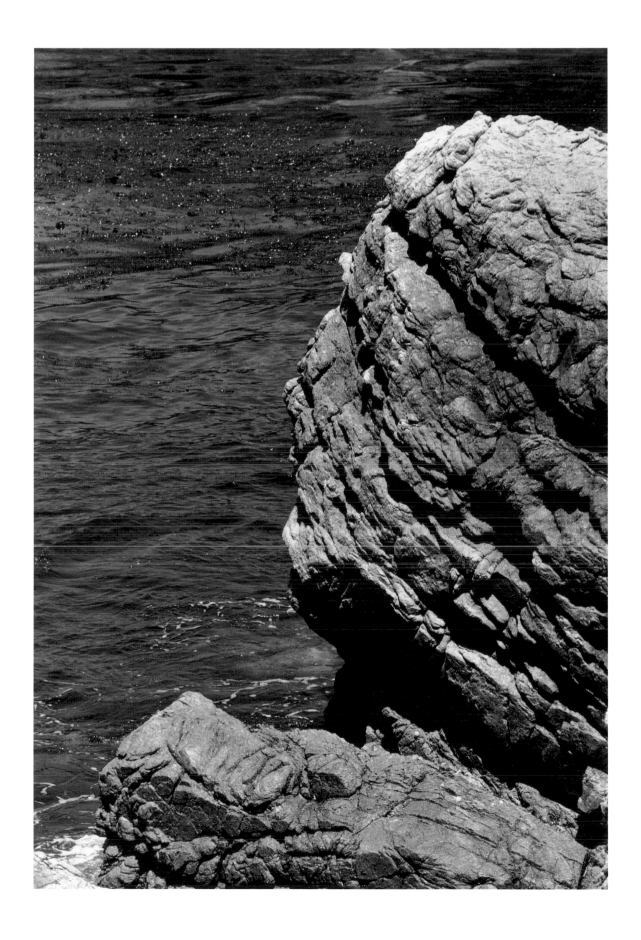

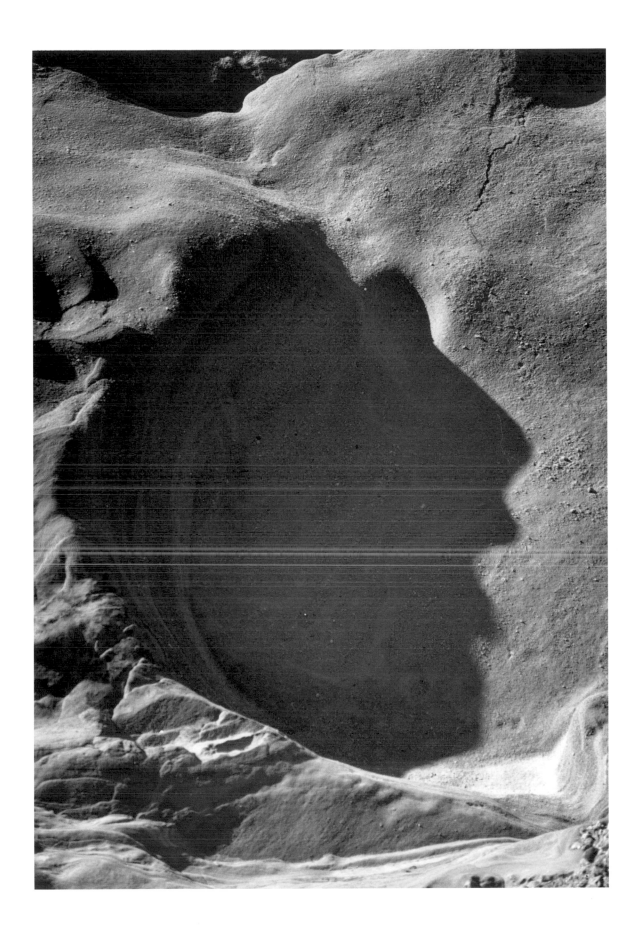

MALE AND FEMALE

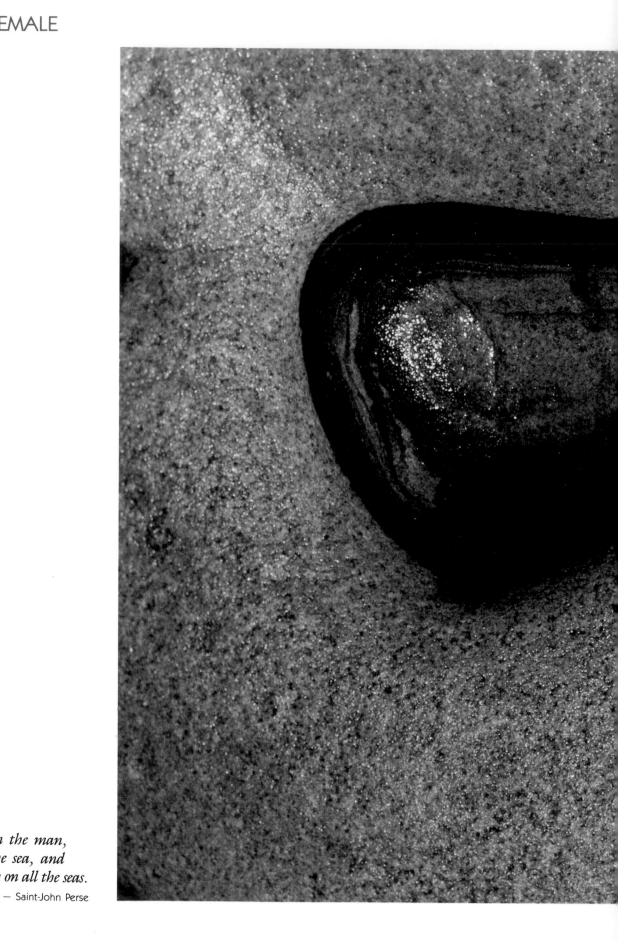

And the woman is in the man,
and in the man is the sea, and
love sails far from death on all the seas.

— Saint-John Perse

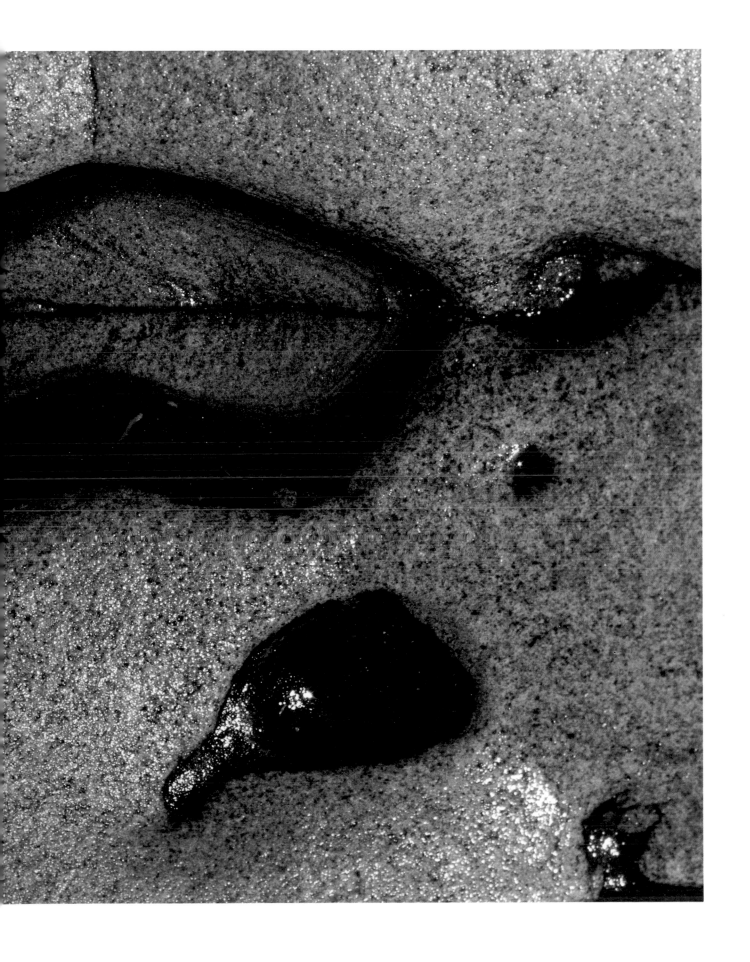

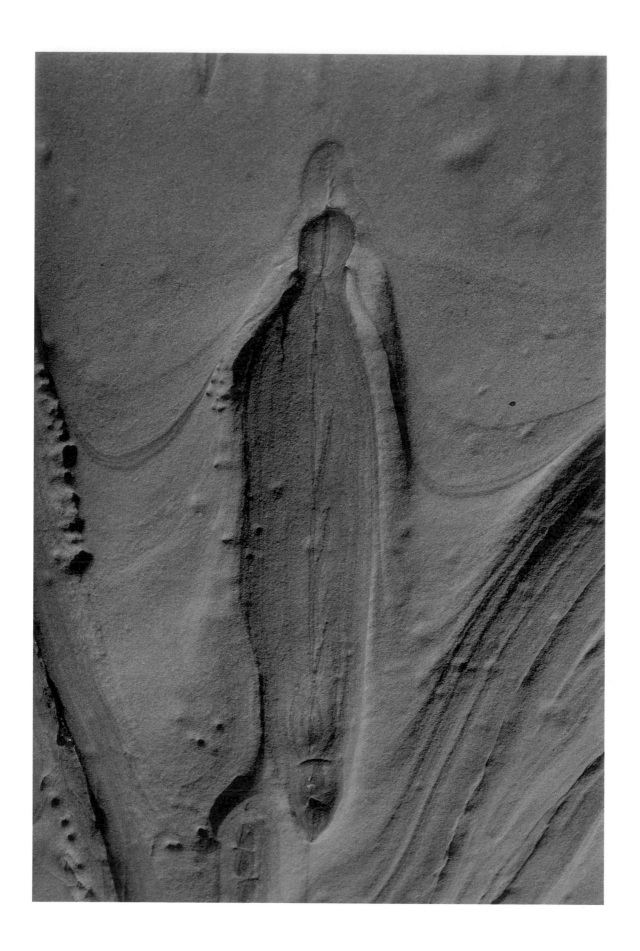

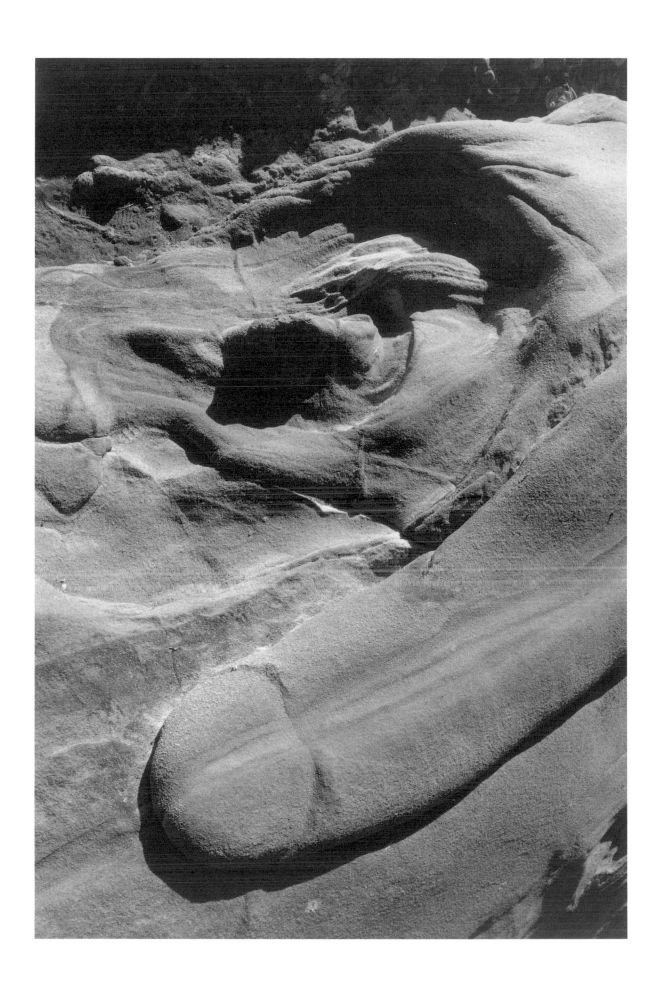

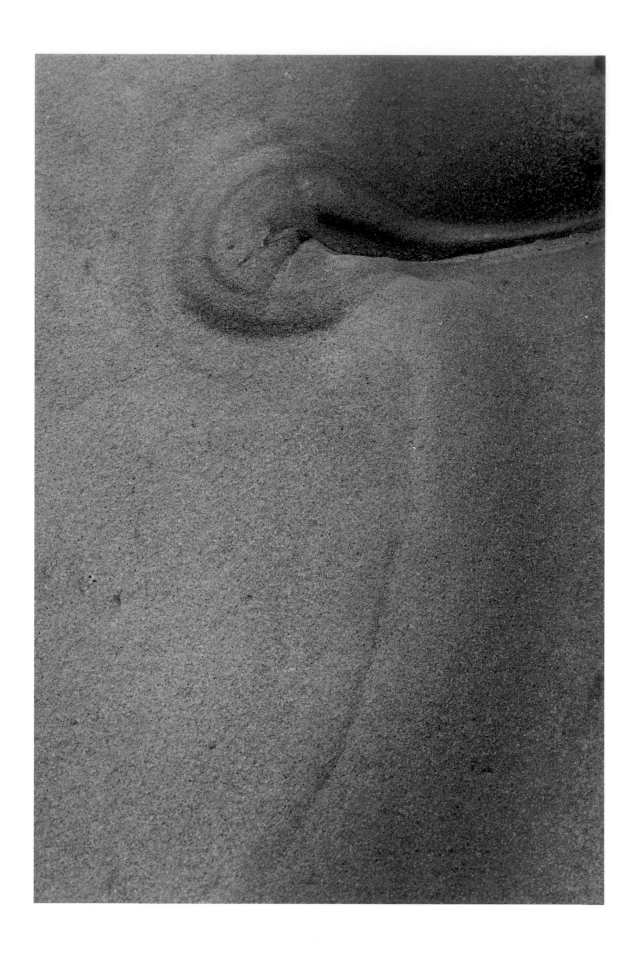

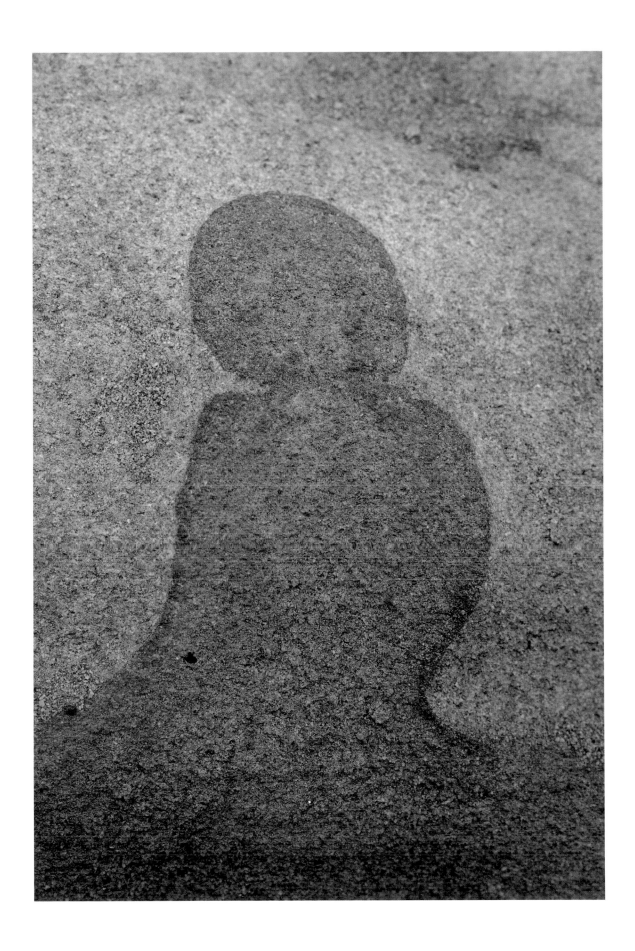

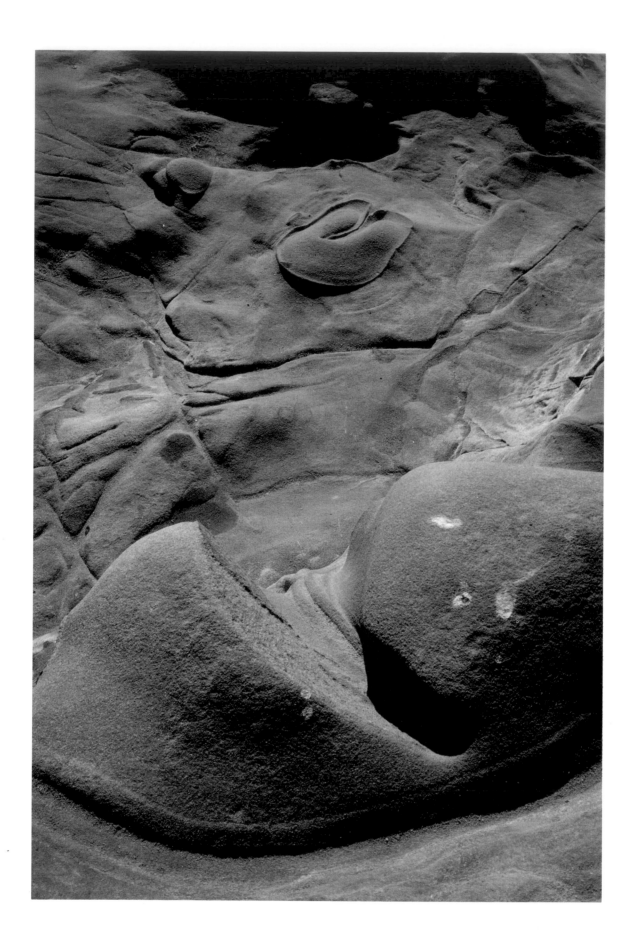

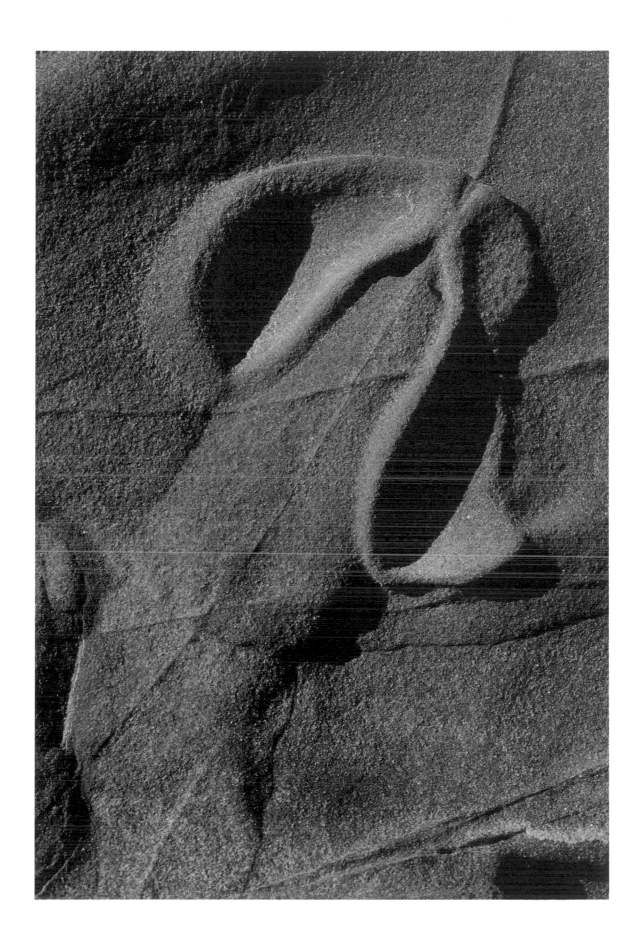

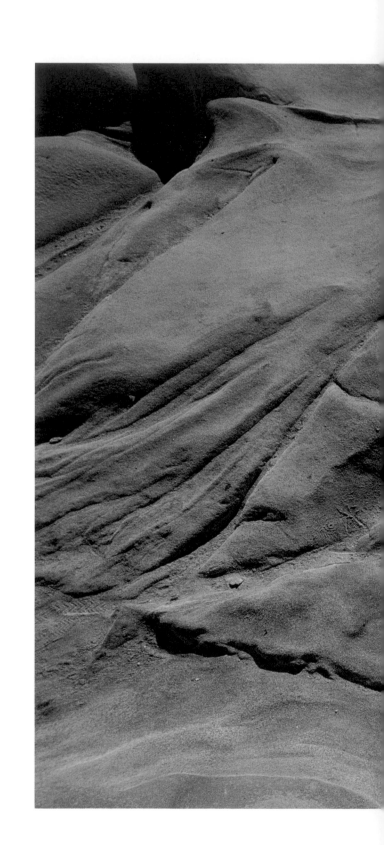

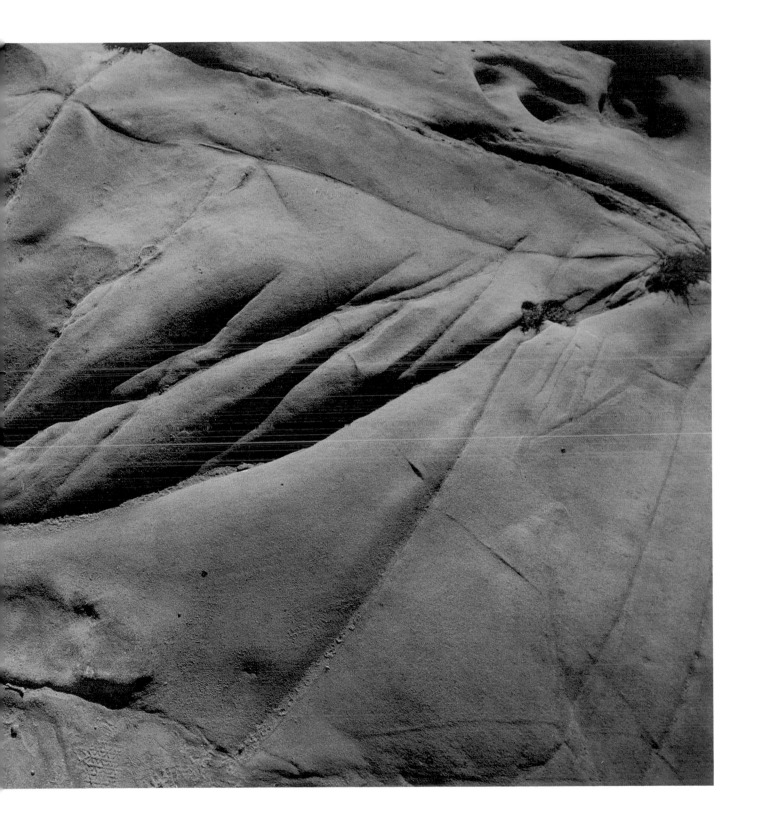

*H*UMAN FORMS

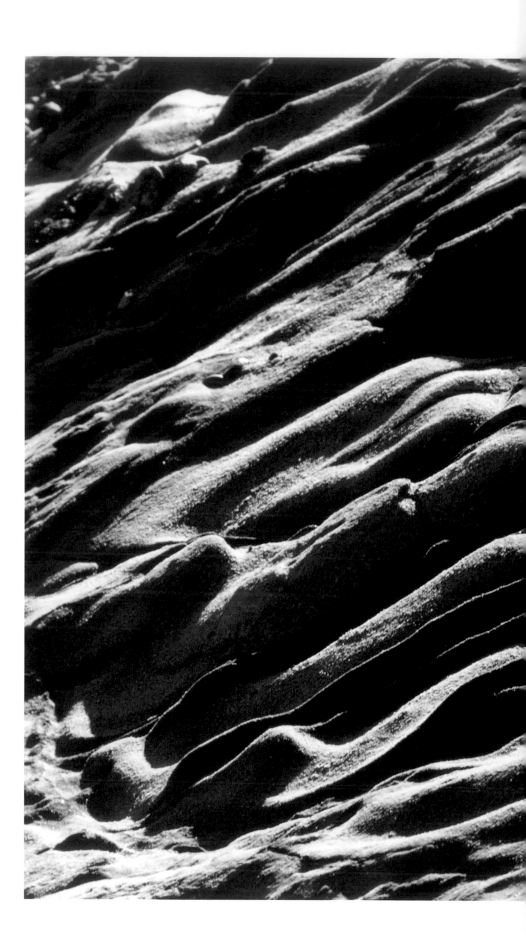

And so it is that the earth, once again a gross and indistinct mass, took shape and modeled itself with new figures of human beings.

— Ovid

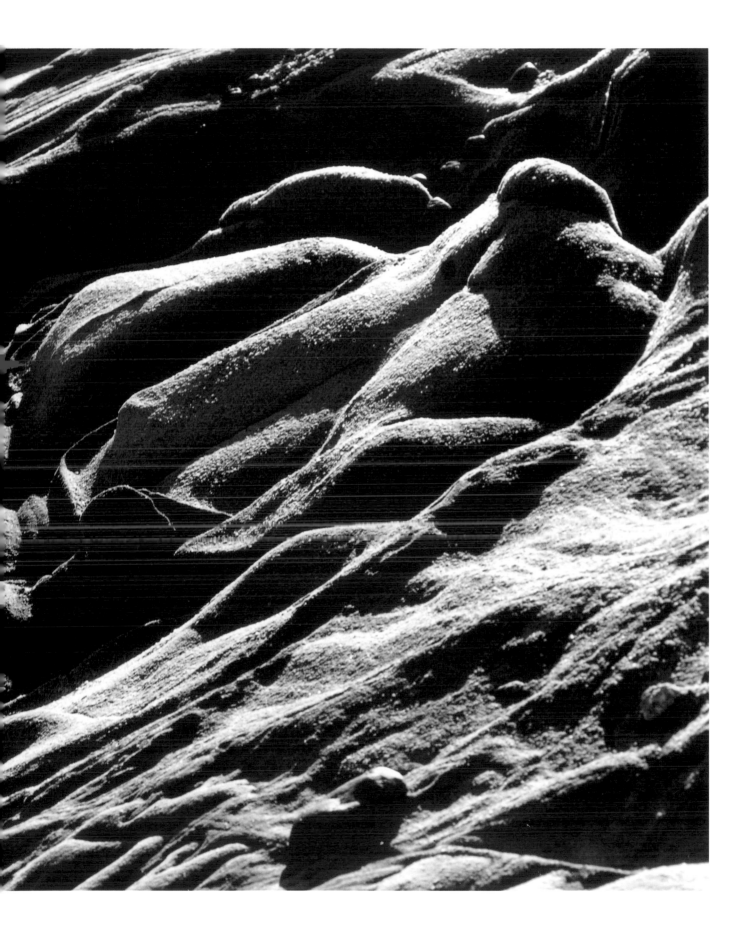

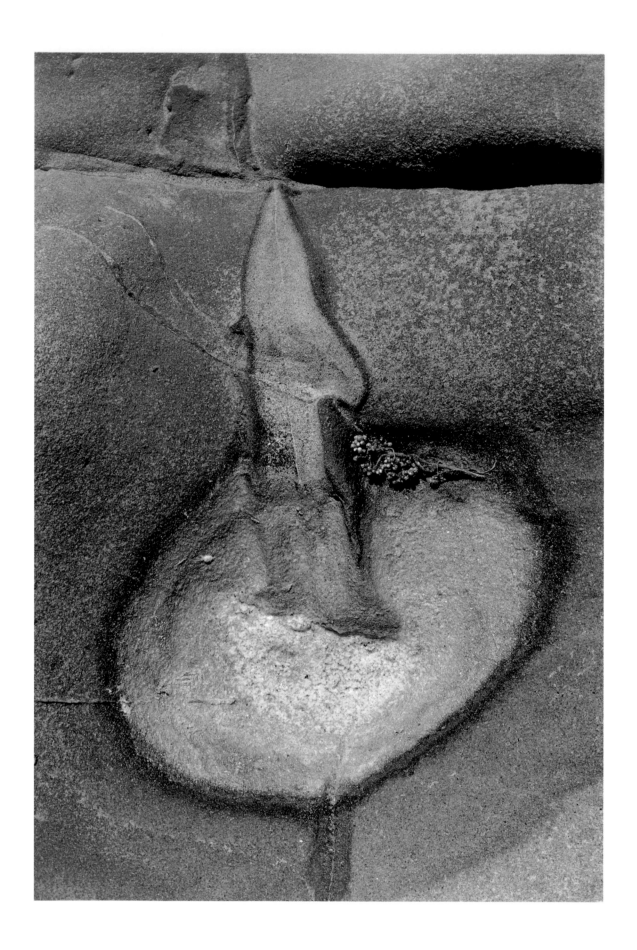

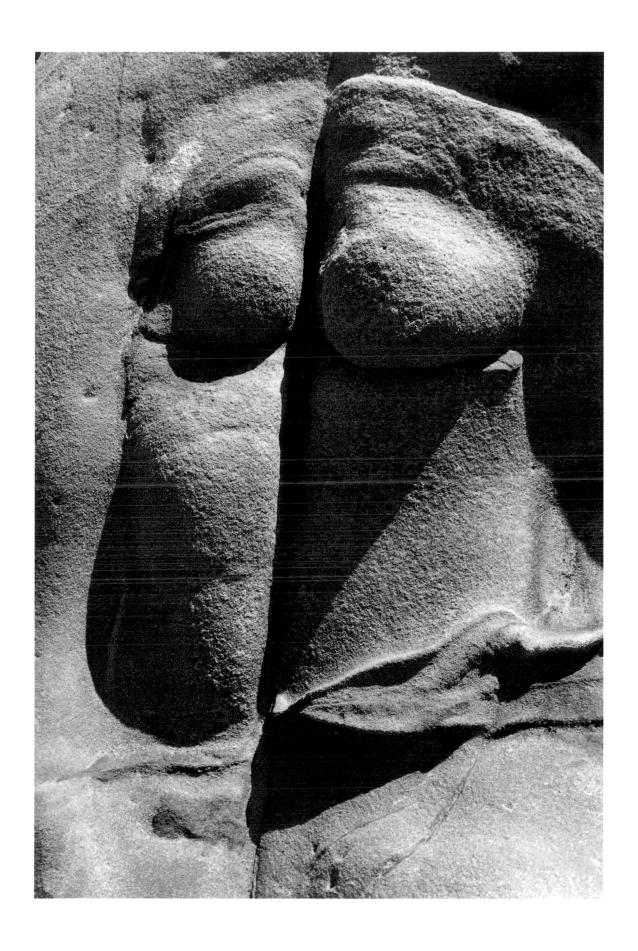

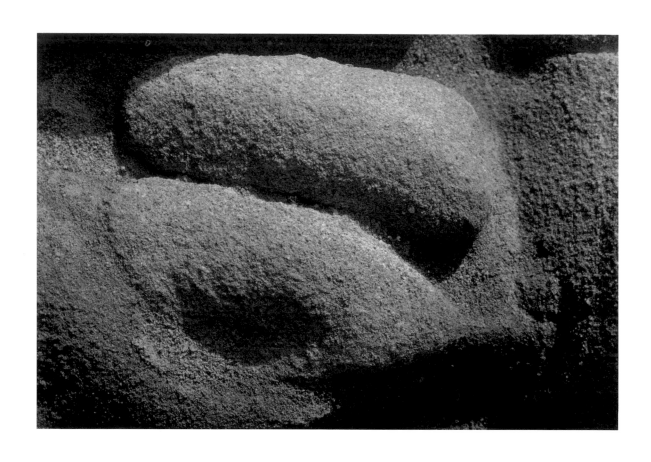

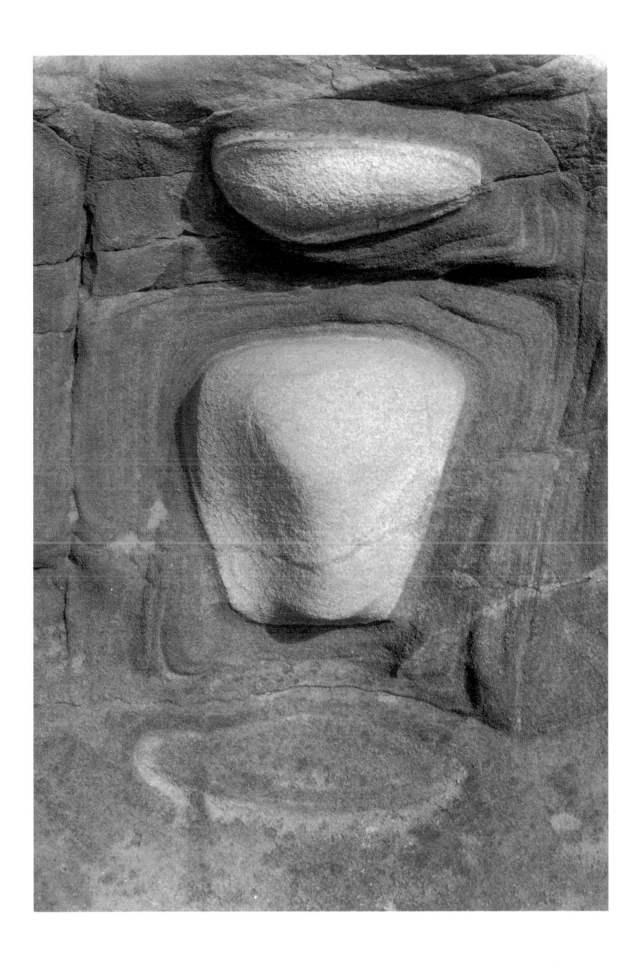

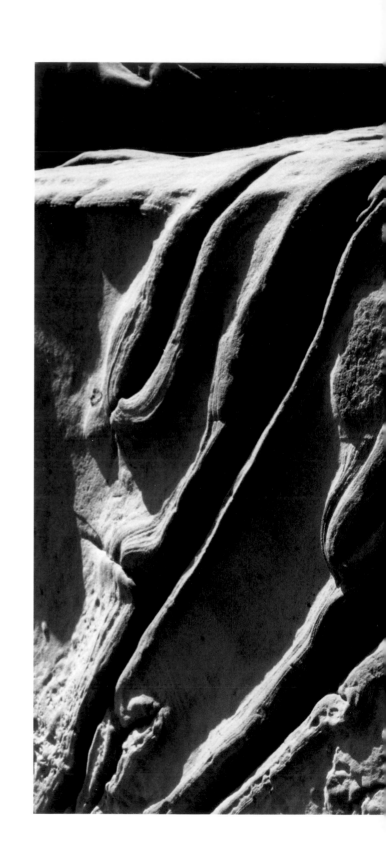

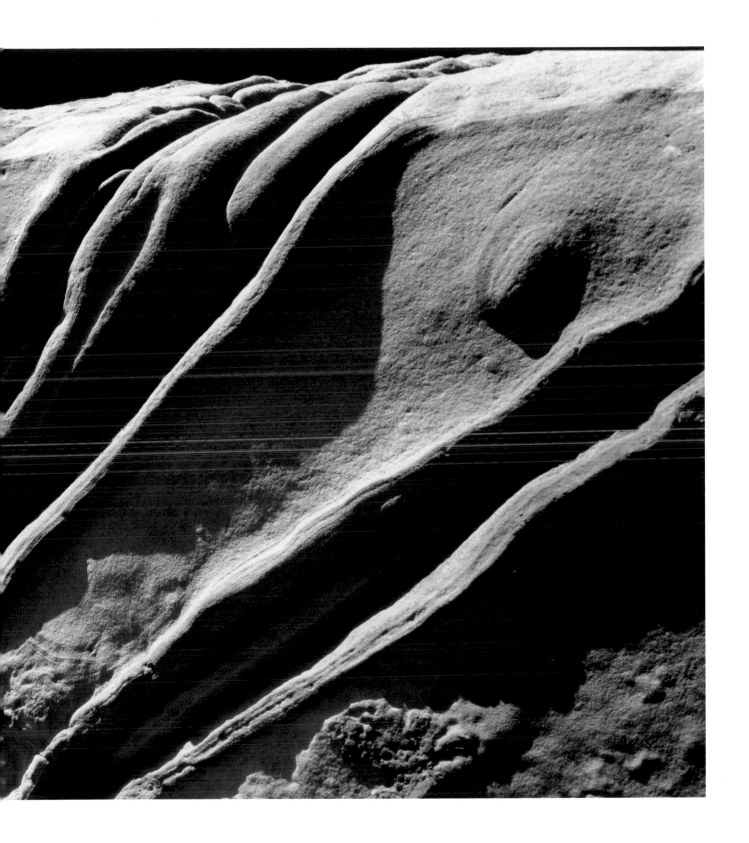

Dreams

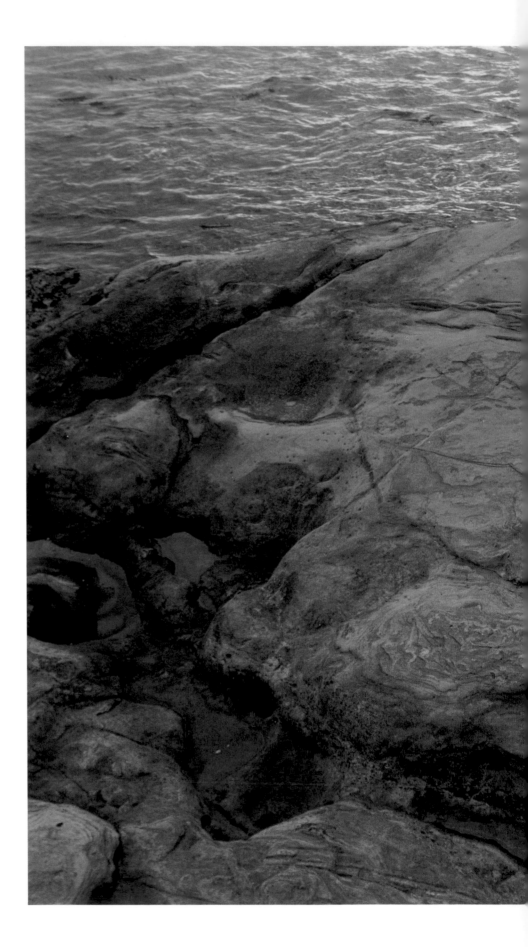

The sea gives tales before giving dreams.

— Bachelard

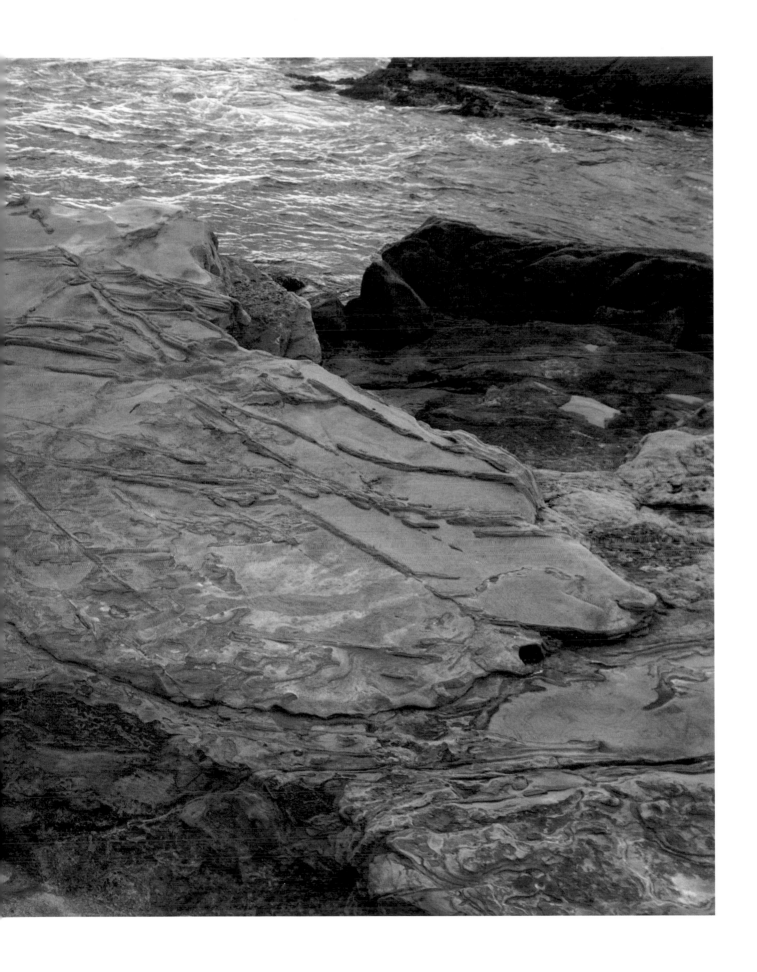

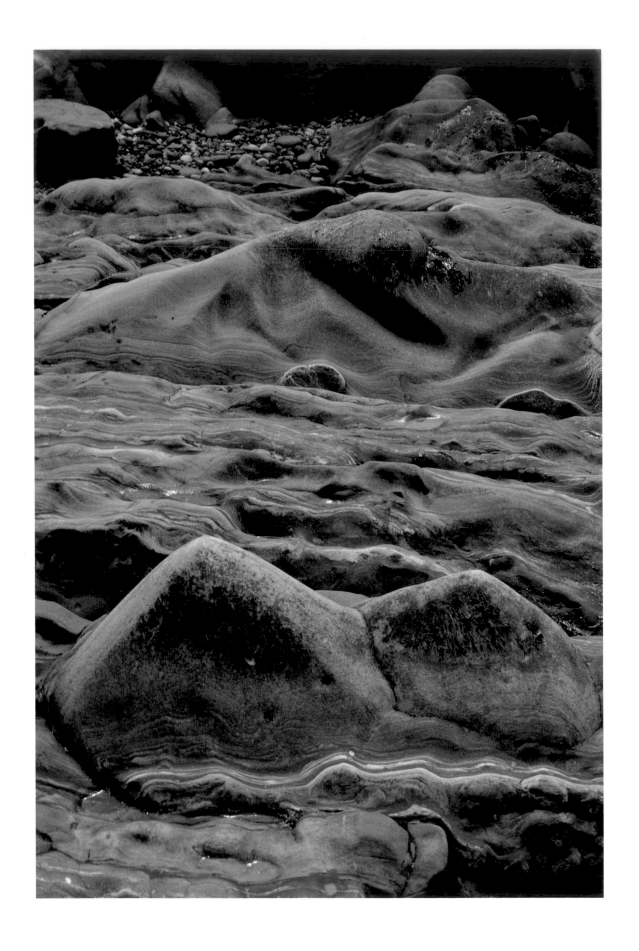

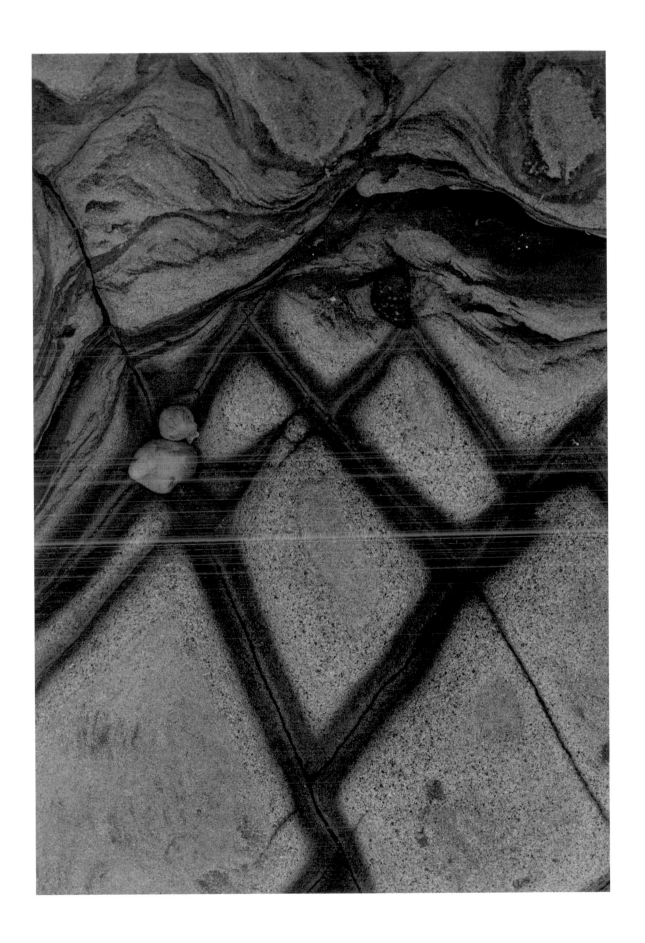

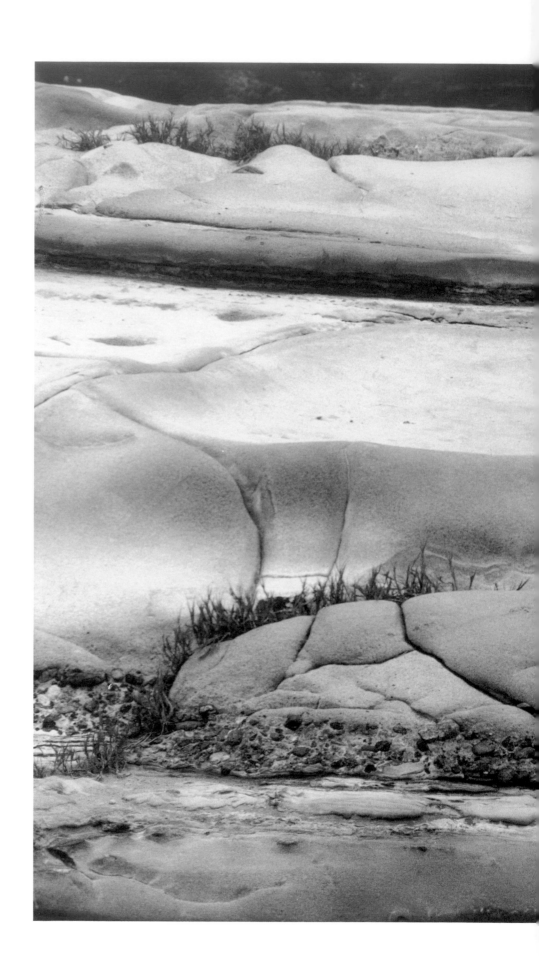

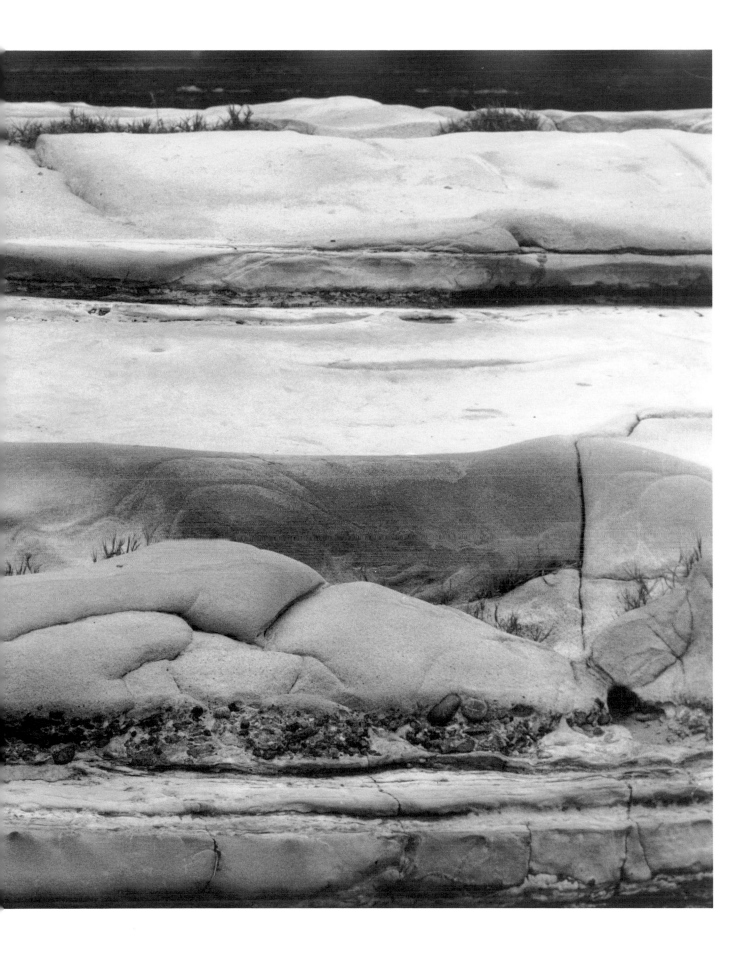

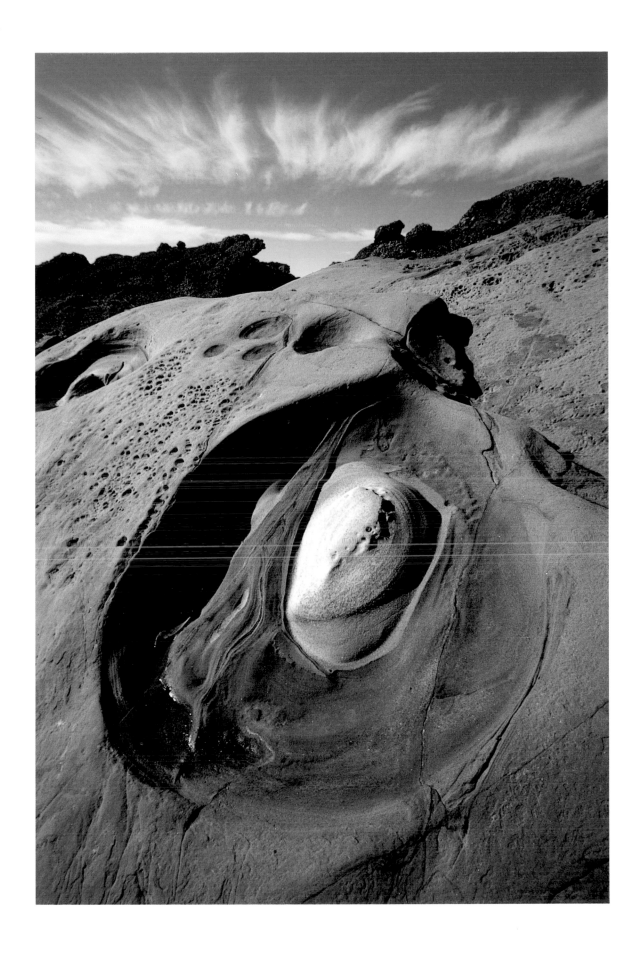

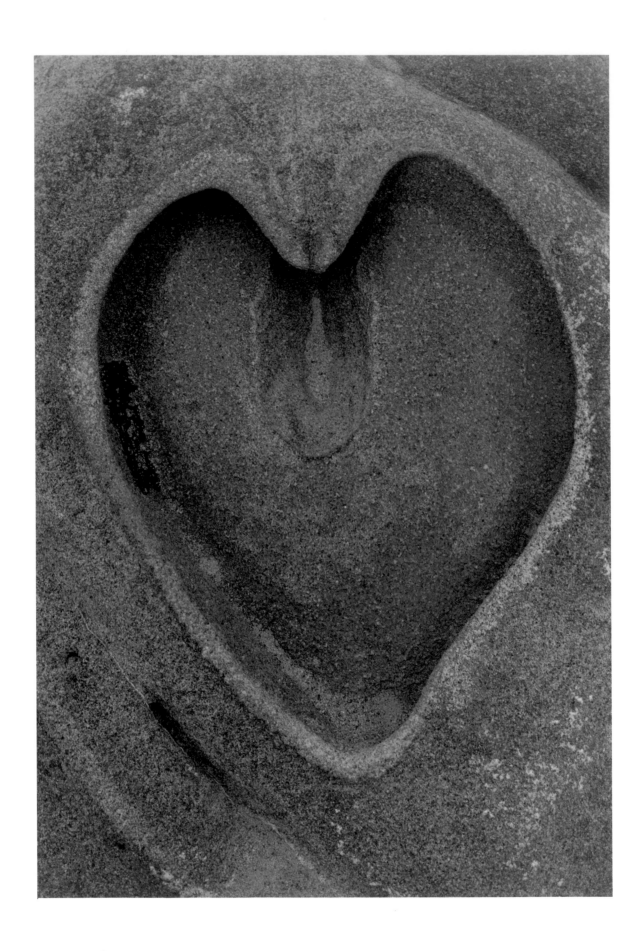

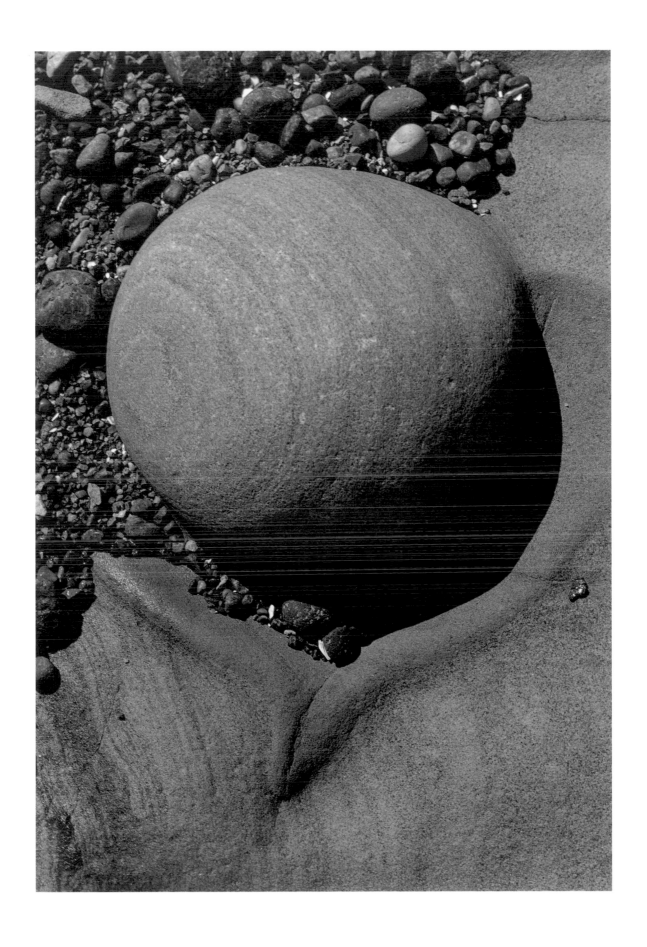

Bestiary

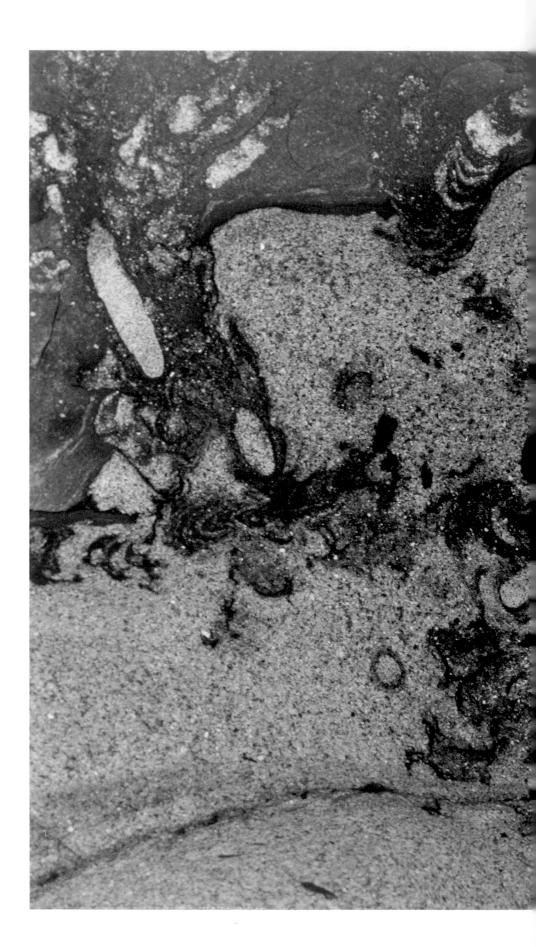

...for the pagan, Nature is nothing more than the surface of the Earth that has been marked... by the footprints of the Gods.

— Roland Barthes

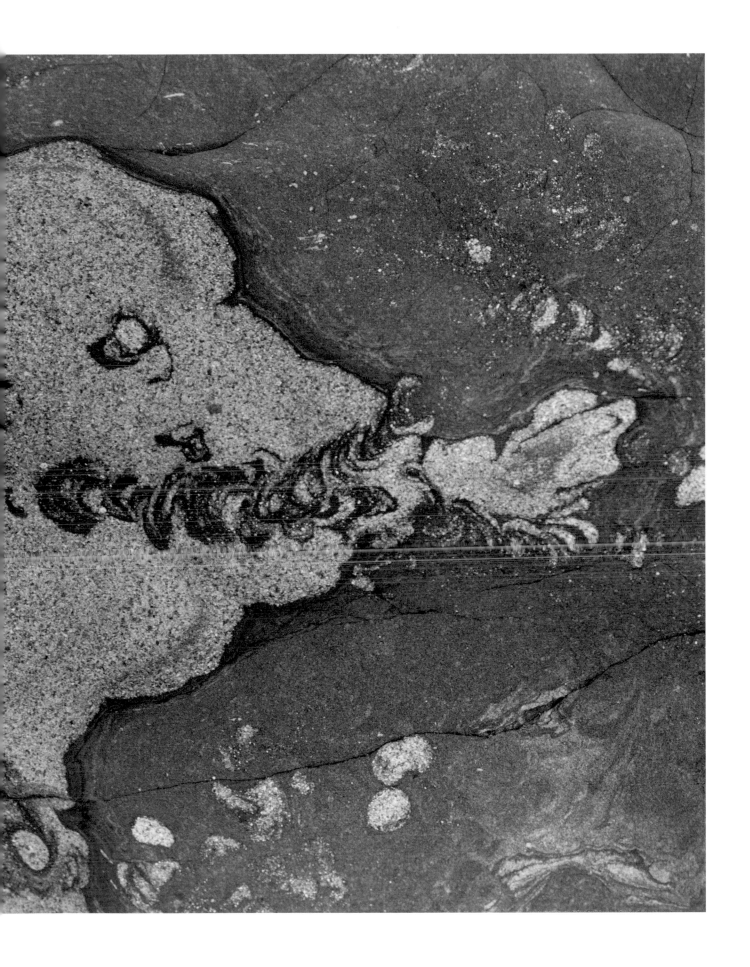

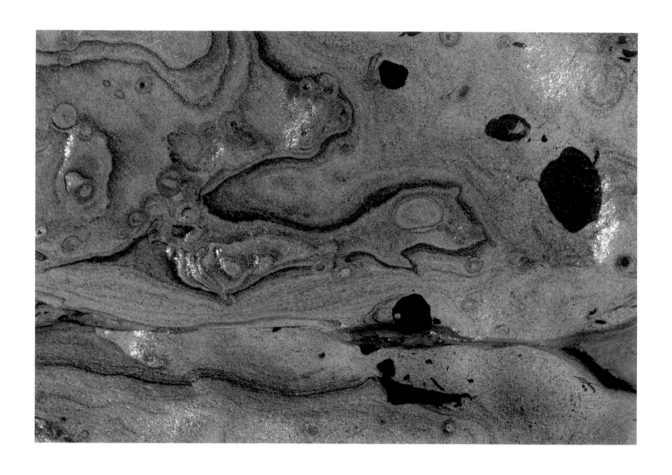

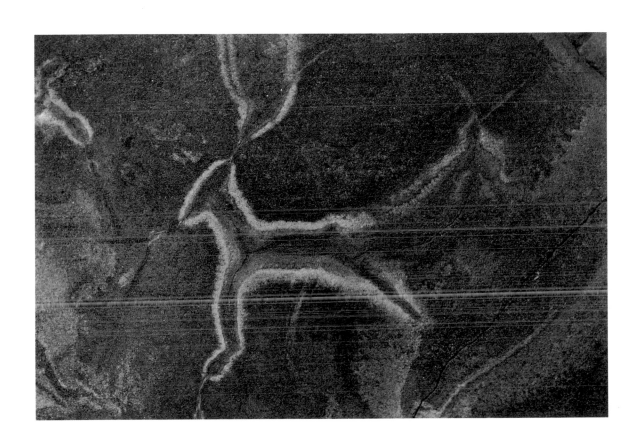

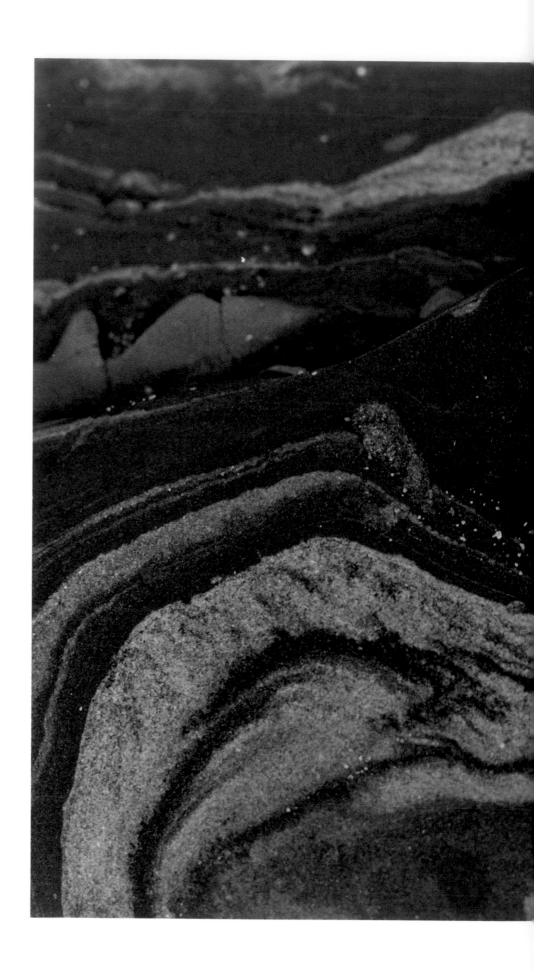

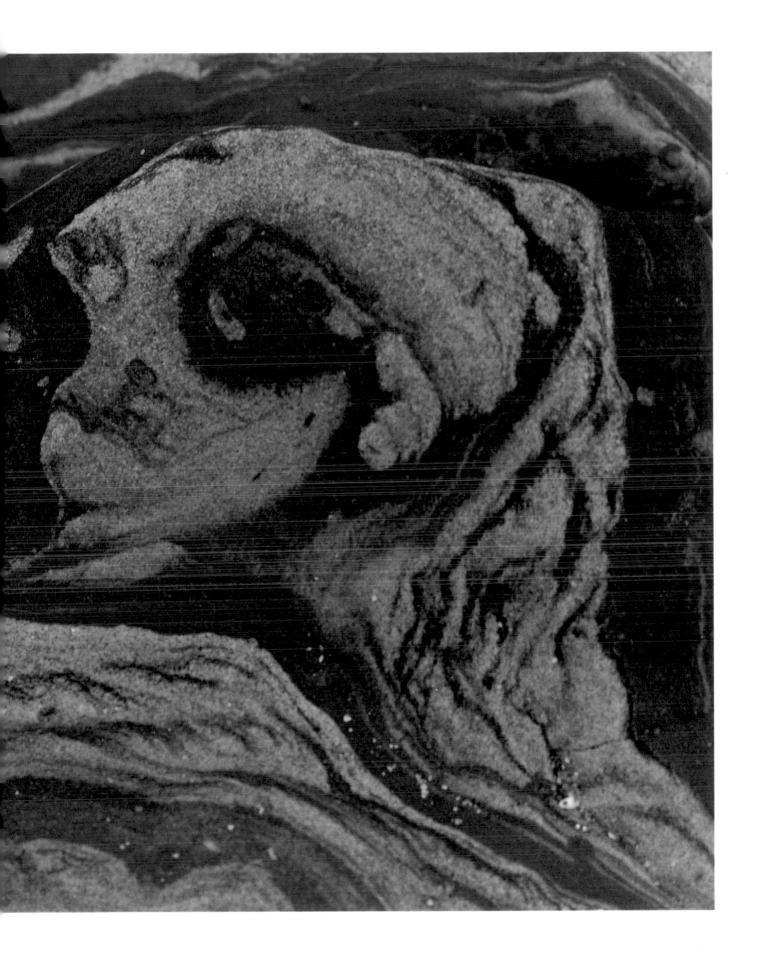

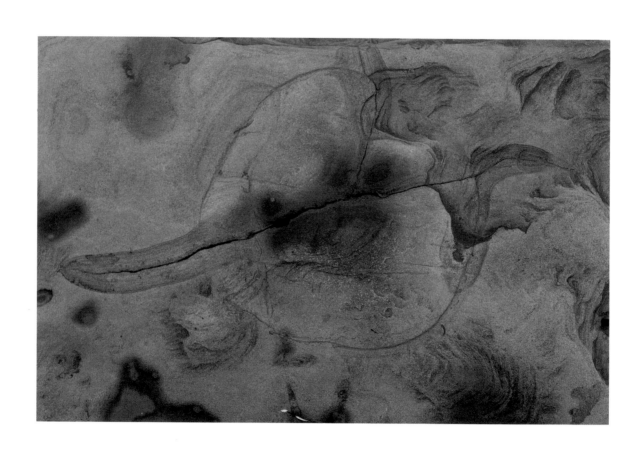

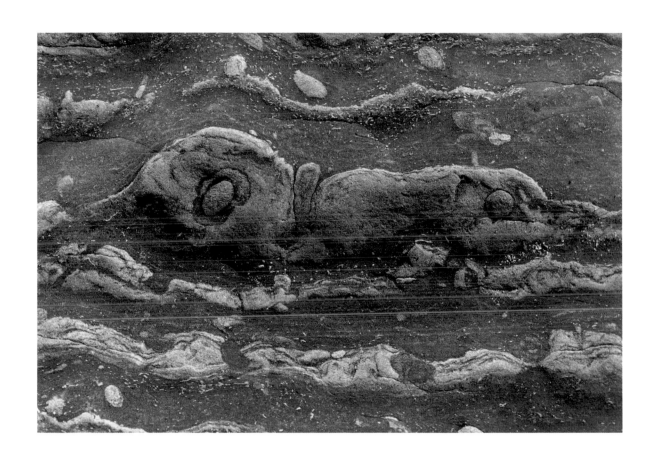

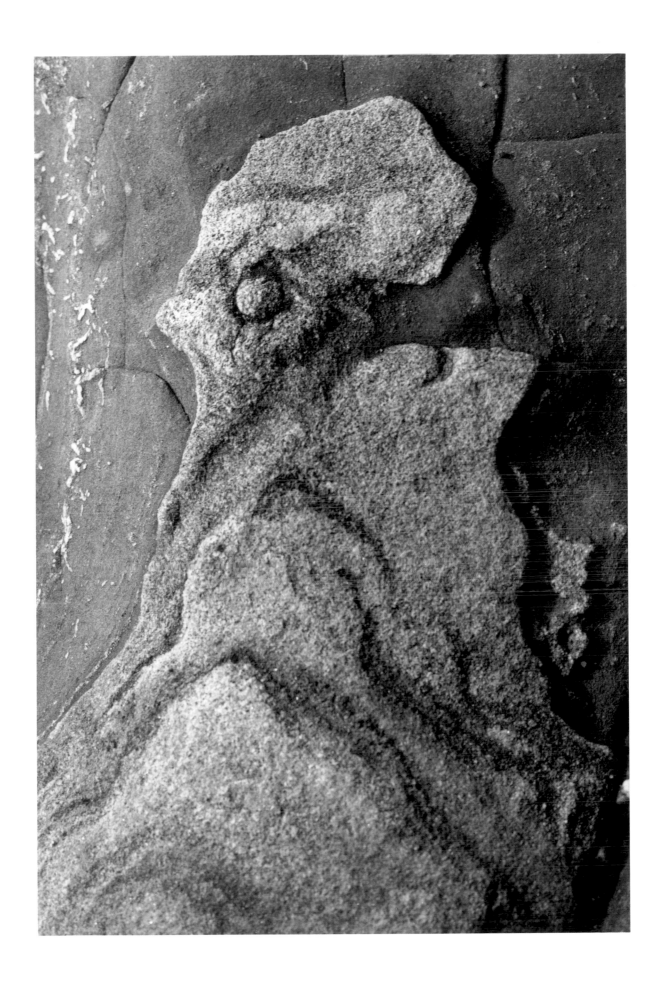

CHIMERAS

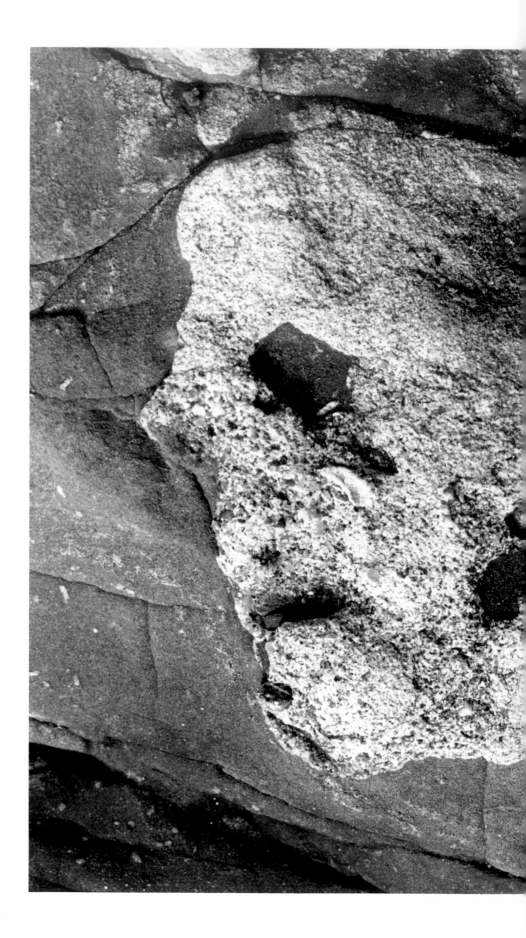

I'll tell you a secret
it was god made you god

in the old way made you
mostly out of fire and

air no man and woman
love could make some-
thing like you....

— James Laughlin

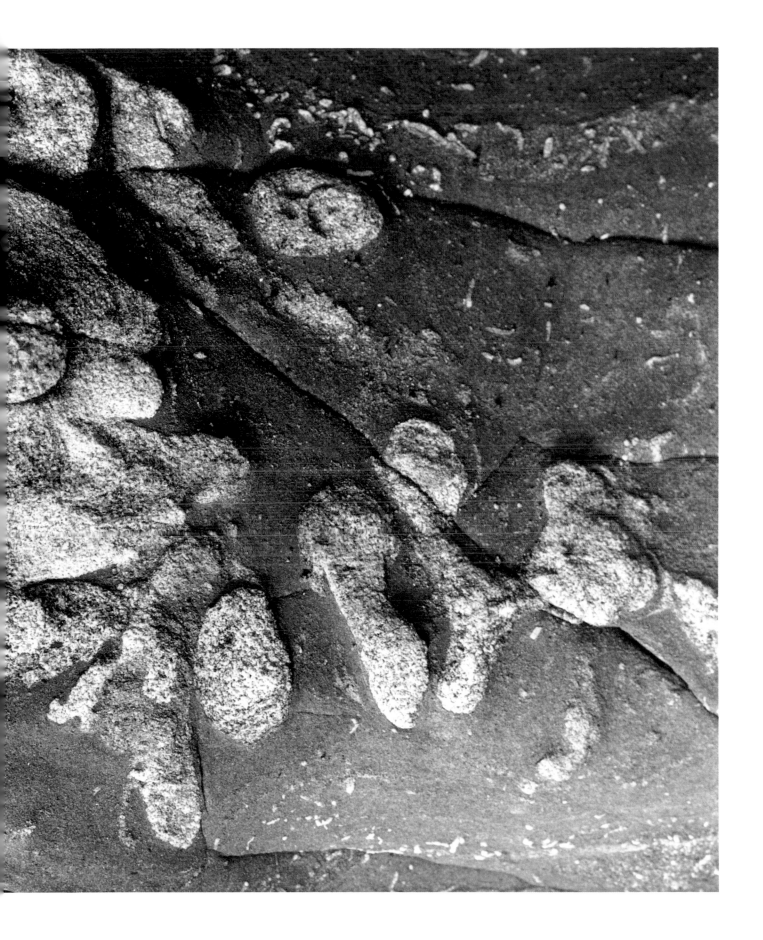

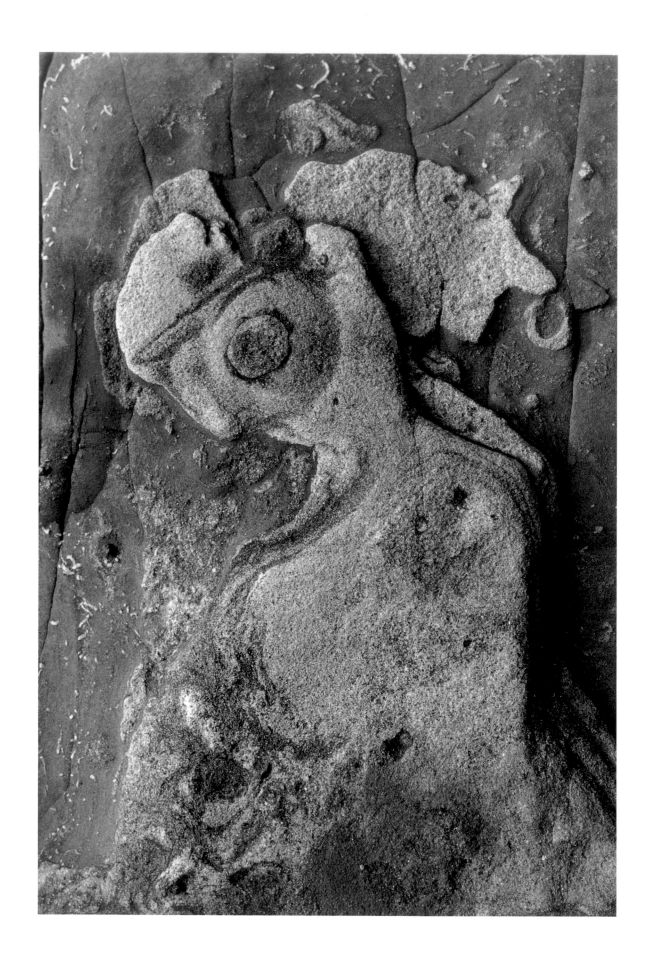

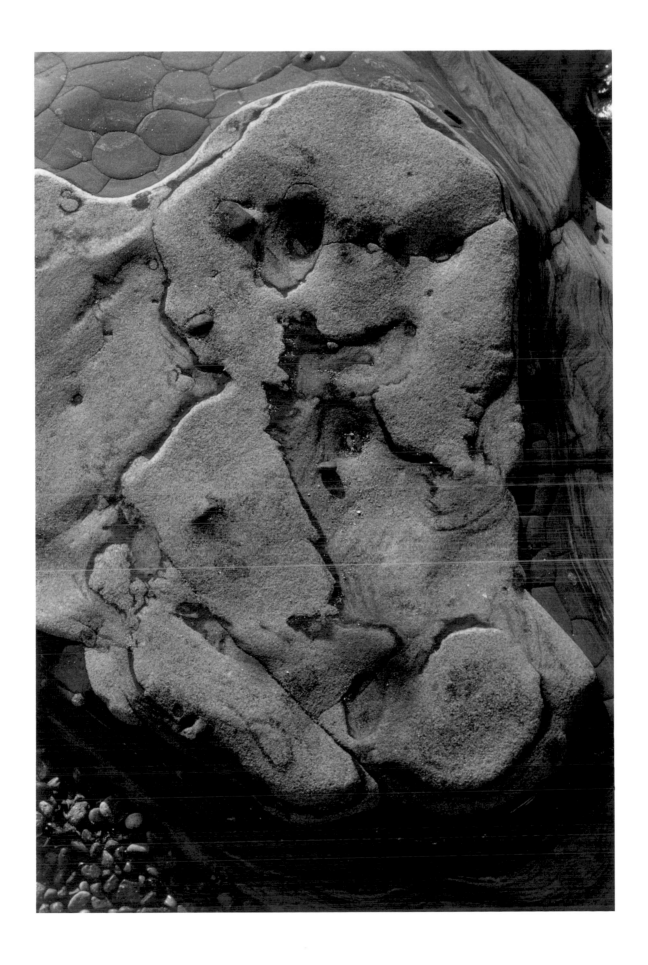

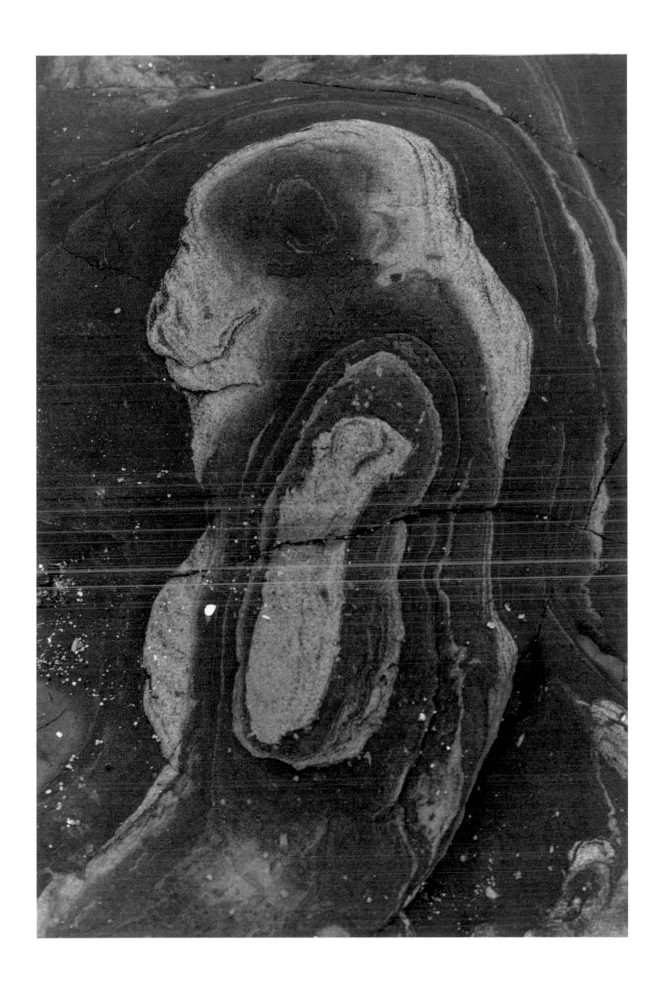

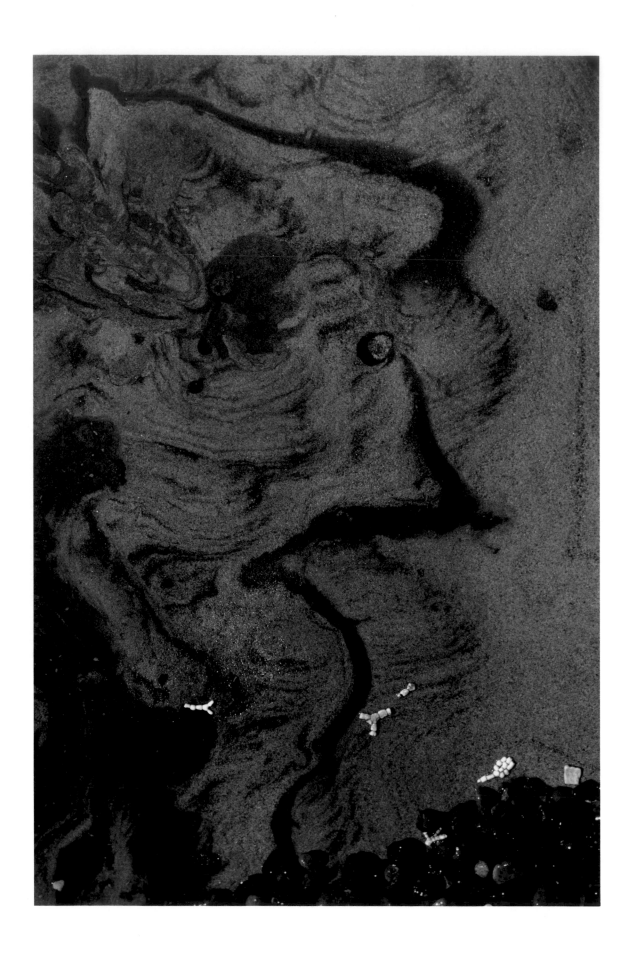

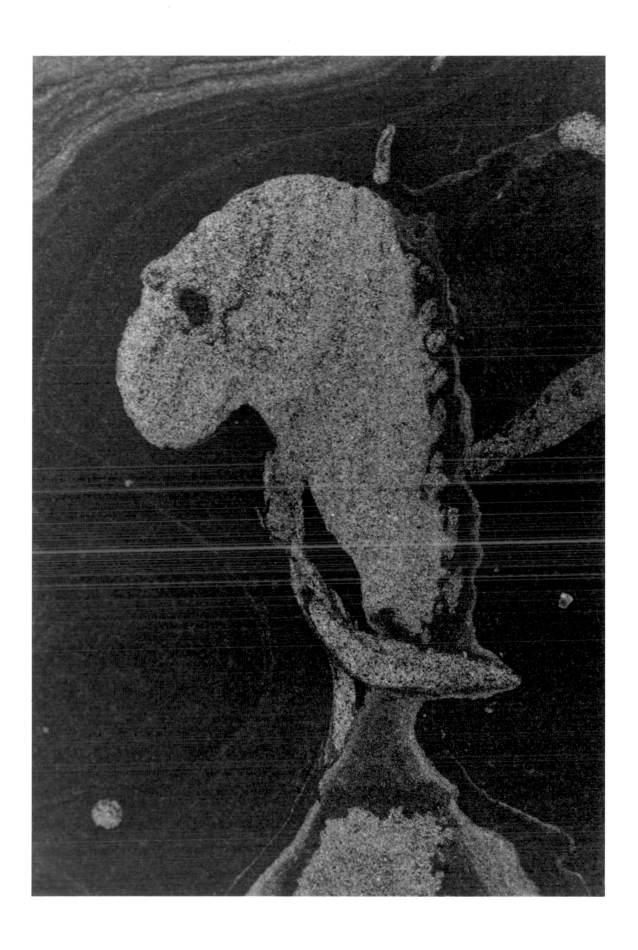

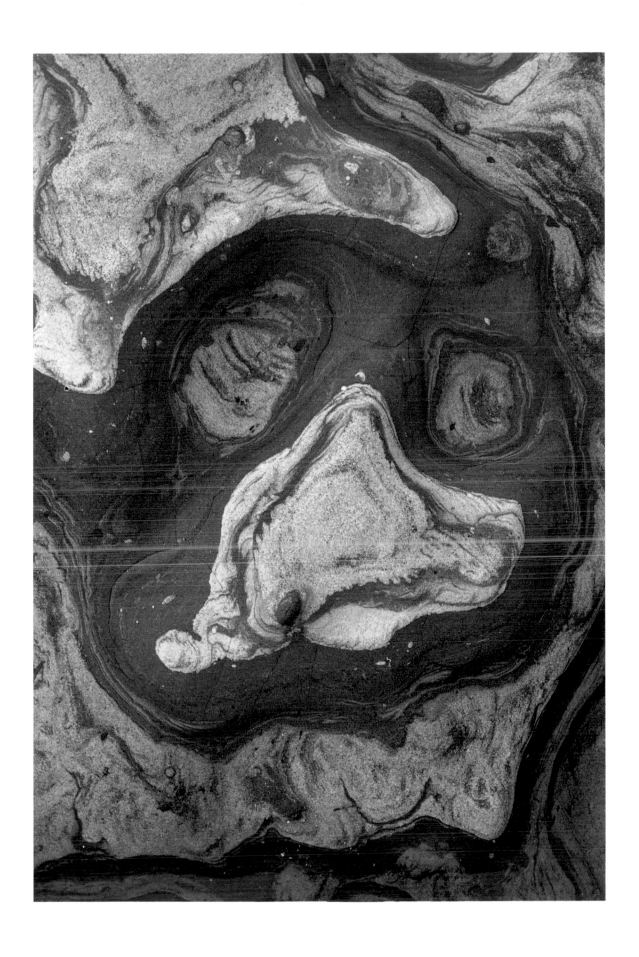

DEATH MASKS

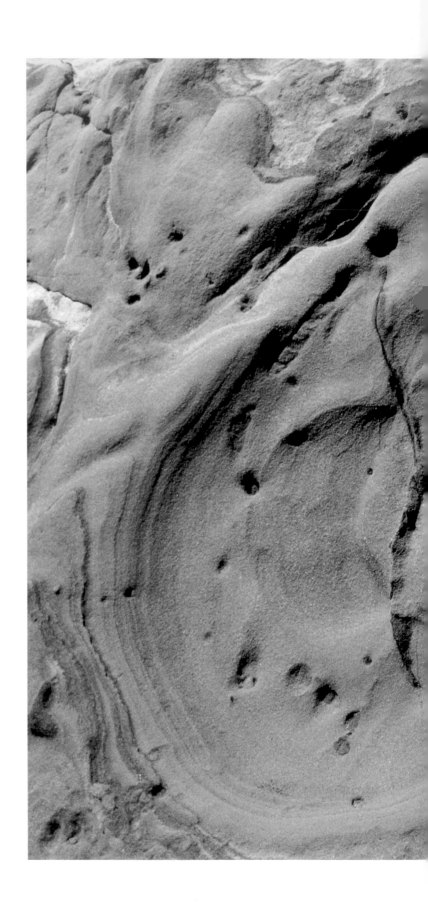

And Death once dead, there's no more dying then.

— William Shakespeare

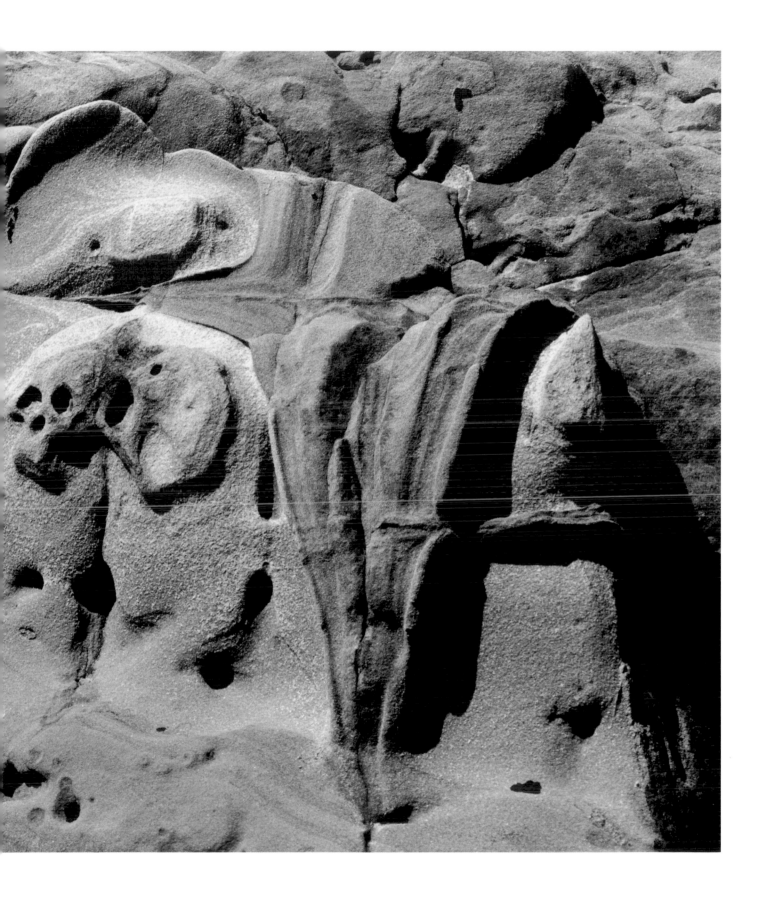

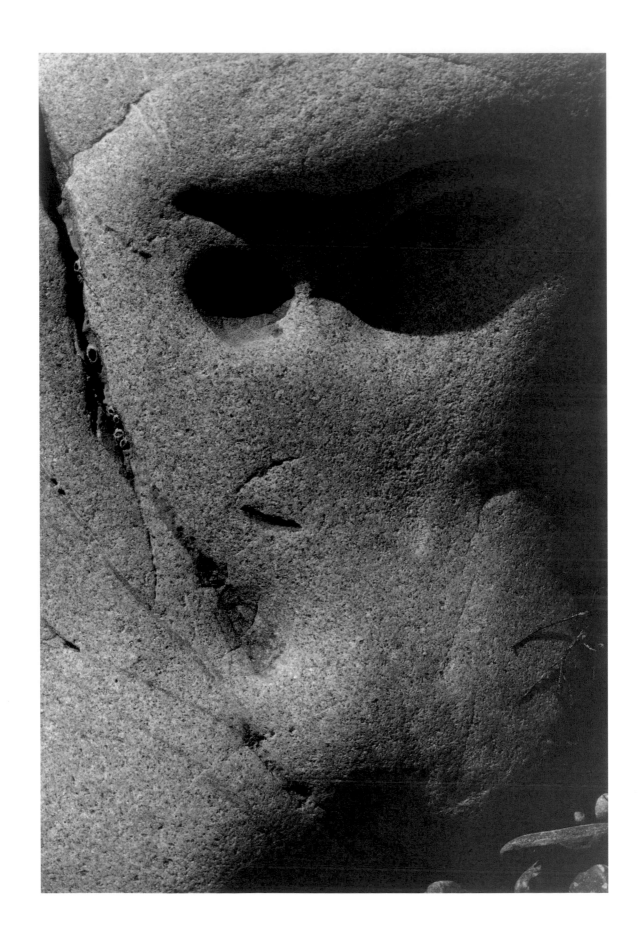

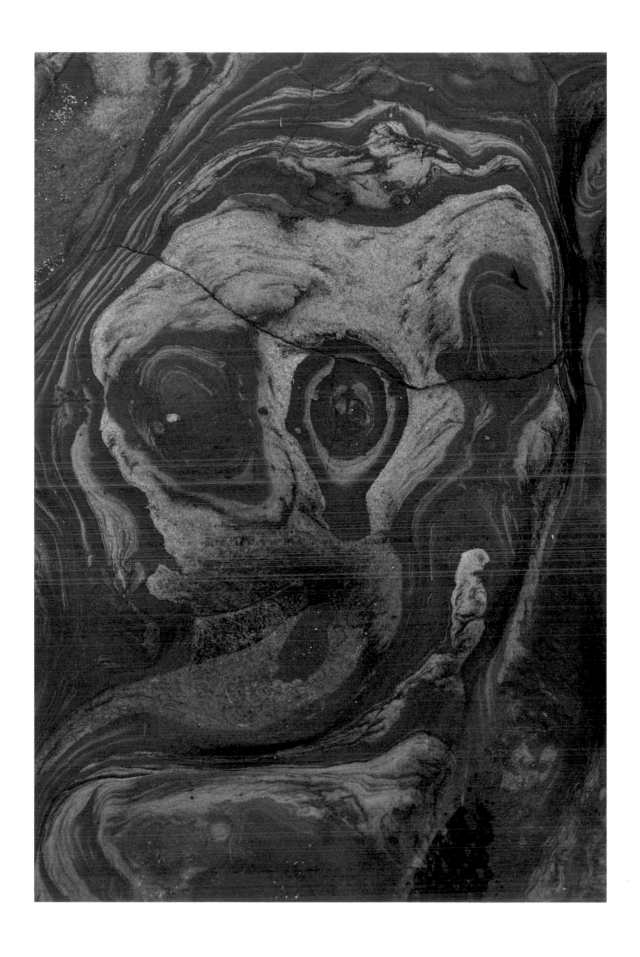

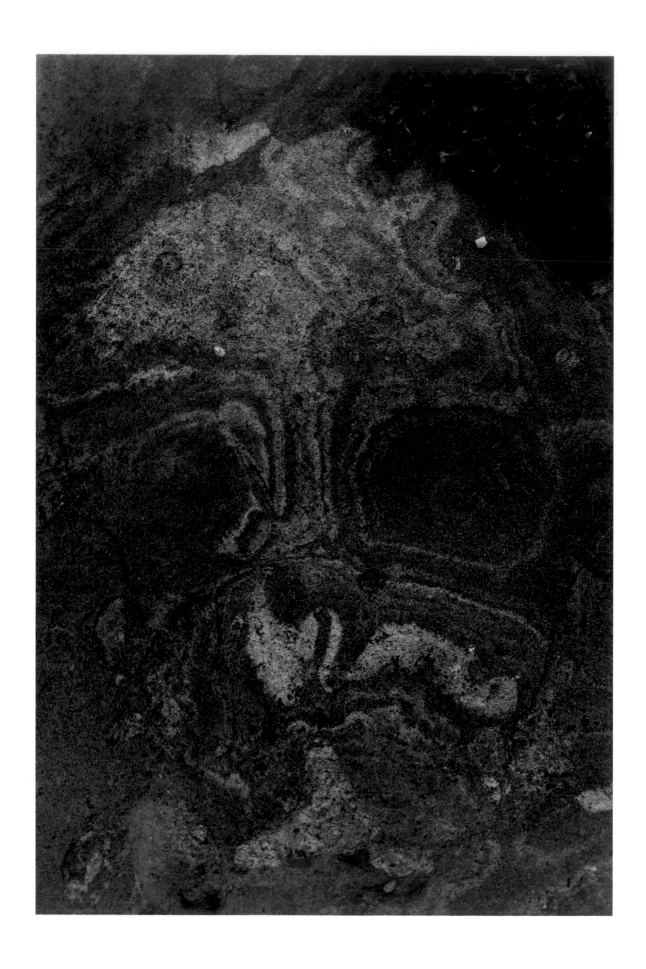

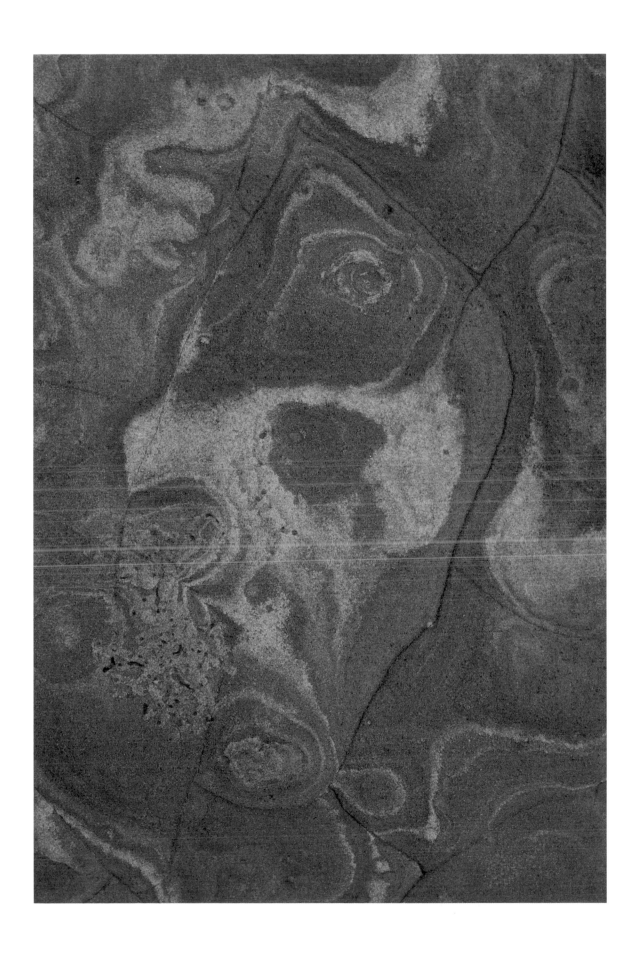

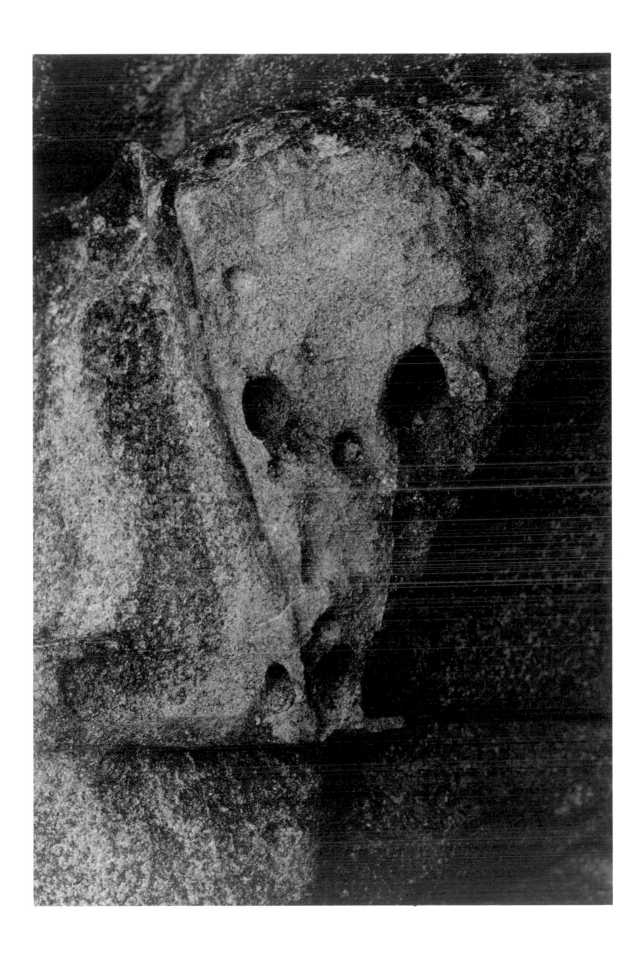

GALAXIES

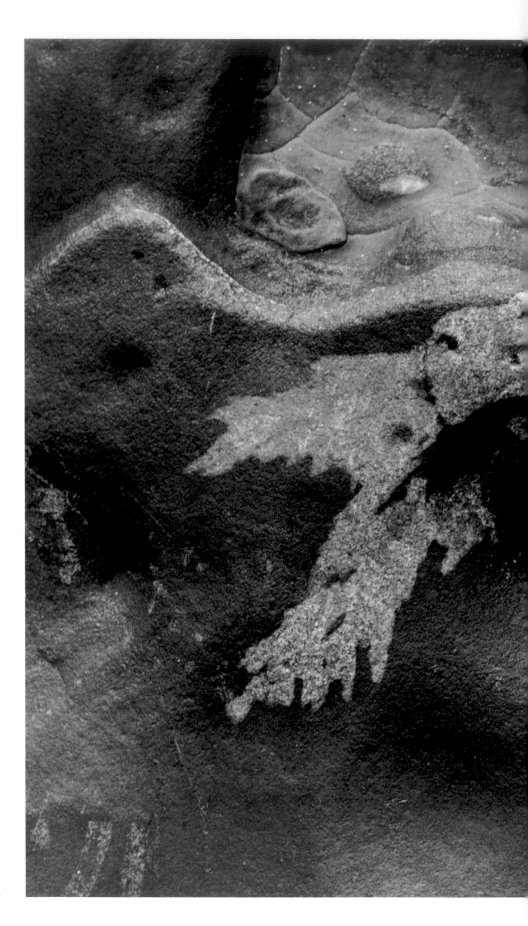

True man emerges from his long crossing through the night and through the day. The divine truth speaks aloud. All the workings of the universe come back to human beings, just as they come back to all living things.

— Jean Giono

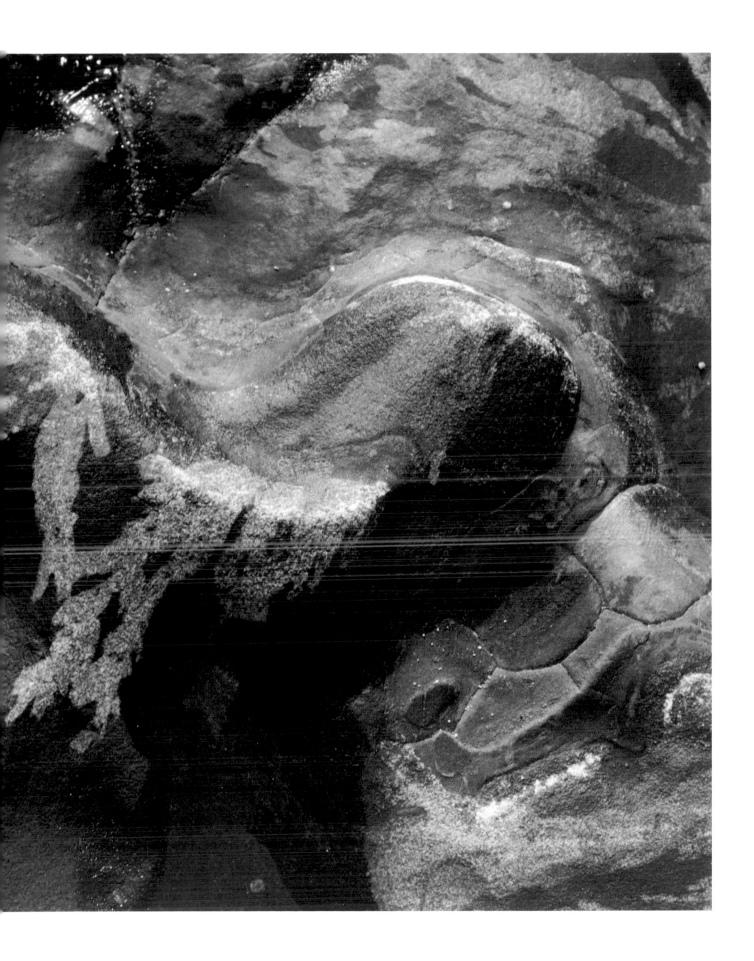

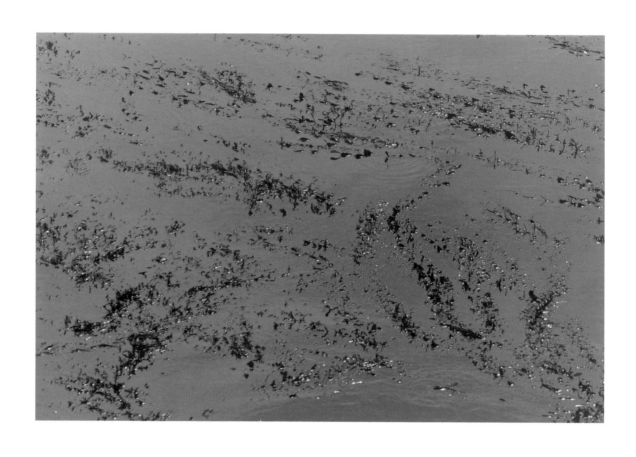

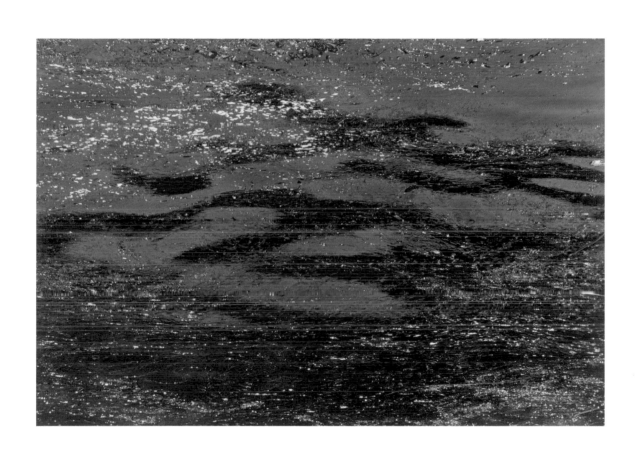

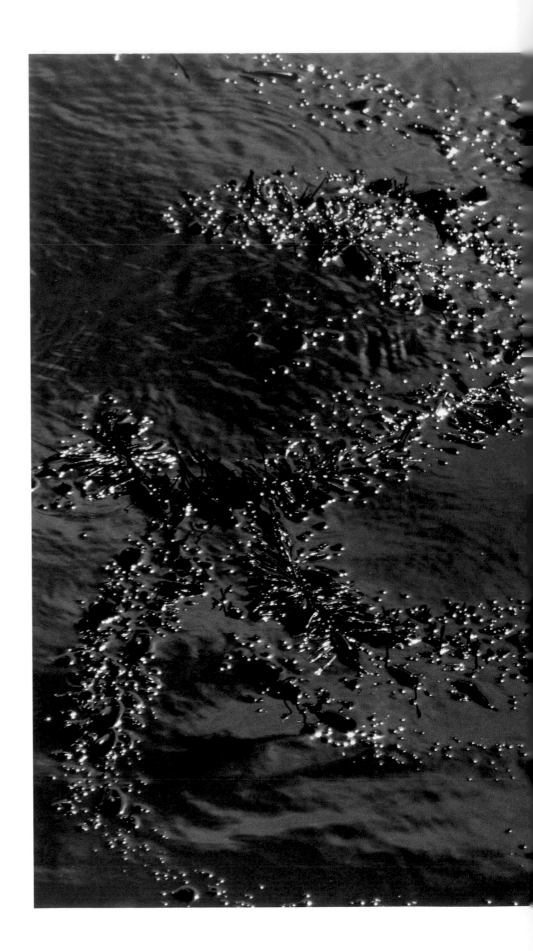

I admired the beauty
While I was human, now I am
part of the beauty.

— Robinson Jeffers

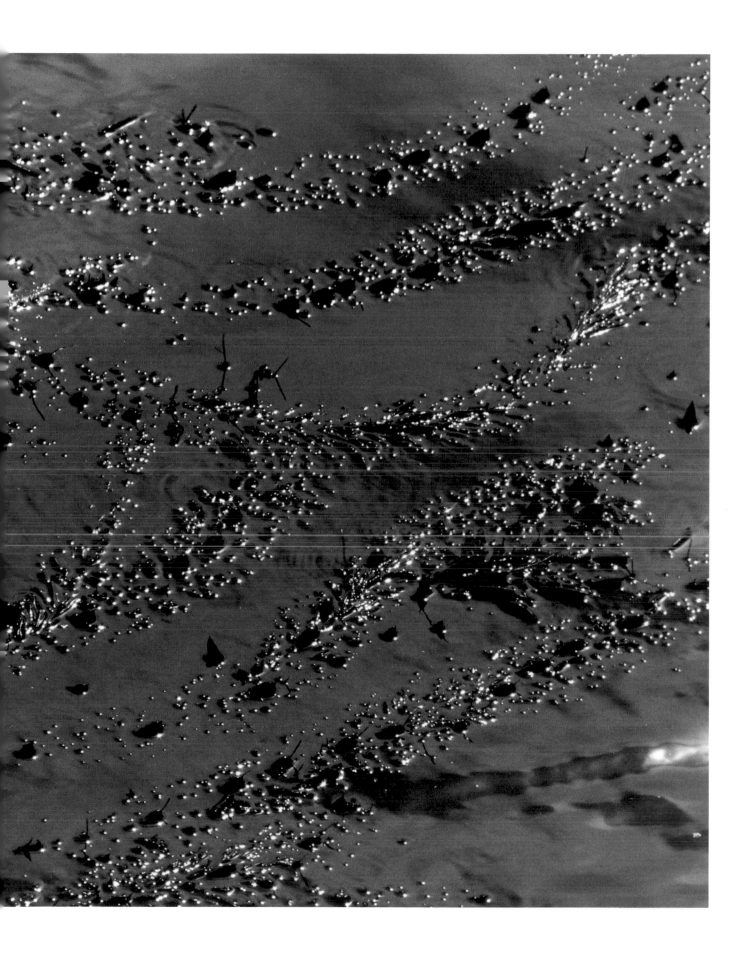

ACKNOWLEDGEMENTS

I wish to express my gratitude to all my friends and relatives who helped me to accomplish this project:

Among them are Judy Dater and Jack Welpott who introduced me to Point Lobos, and Wynn Bullock, Ansel Adams and Neil Weston; Virginia Adams who hosted me several years running while Ansel was giving me advice, even driving me to locations or to the airport; Bill Turnage, Andrea Gray, Jim and Mary Alinder, Mrs. Salinger and Lilette Ripert, David Featherstone, Linda Troeller, Vikki Ericks, Norman Locks, King Dexter, John Sexton, Chris Rainier, Alan Ross, Carol Chapman, Sybil Forest, Larry D. Gordon, Peter Riva, Jean Dieuzaide, Carol and Craig Stevens, Catoune and Edouard Didier, Dr. Julian Wilmot Wynne, Jane Murray, and Jim and Pamela Knight;

For their advice and encouragement, Ralph Gibson, Weston Naef, Grace Mayer, Karel Appel, Cornell Capa, and Shirley Burden;

For their passionate involvement in the project, Earl and Anita Starkoff, who wanted this book to be published;

For his participation in the project, Ray de Moulin, Vice-President of Eastman Kodak Company (Rochester), with the assistance of Marianne Samenko, without whom this book and exhibition would not have been published or shown;

For designing the book, David Brock, and David Reierson and Laura Pike for making the separations, and Walter Huckabee, Maggie Rose, Ted Swinford and Don Gaitan for printing the exhibition;

For their help through the years as personal assistants — Teresa Engle, Jody Johnson, Dominique Woisard, Laurent Millet, Victoria Clay, Michèle Szoka, and Jan Jonker;

For her literary advice, Christiane Baroche, and for his superb contribution and knowledge of Robert Louis Stevenson, Michel Le Bris, whose books on this author Stevenson have enriched my vision; and Jim Hughes for his essay;

For being the first in the world to show these photographs at the 1989 exhibition in Arles — Jean-Maurice Rouquette, President of R.I.P. Arles, Claude Hudelot, Art Director, and Dan Jacobi, assistant.

Lucien Clergue
Arles, February, 1989

* * *

The exhibition of *Footprints of the Gods* and the exhibit catalog have been sponsored by Eastman Kodak Company, Professional Photography Division, to celebrate the 20th Anniversary of the *Rencontres Internationales de la Photographie,* and to honor its founder, Lucien Clergue. The exhibition premiered as the featured exhibit at the *Rencontres* in Arles, France, on July 3, 1989.

The original body of work was photographed on Kodachrome 25 and Kodachrome 64 35mm Professional Film. The exhibit was printed from Kodak Vericolor Internegative Film 4114, Type 2, processed with Kodak Flexicolor Chemicals, Process C-41, using Kodak Ektacolor Plus paper processed with Kodak Ektaprint 2 chemicals.

The author and publisher gratefully acknowledge the generous support of Eastman Kodak Company without which this exhibit would not have been possible.

Lucien Clergue and Iris Publications, Inc.
Boca Raton, Florida